Paolo Martegani -

Digital Design
New Frontiers for the Objects

Birkhäuser – Publishers for Architecture
Basel • Boston • Berlin

Translation from Italian to English: Darragh Henegan, Rome

A CIP catalogue record for this book is available from the Library of Congress, Washington D.C., USA.

Deutsche Bibliothek Cataloging-in-Publication Data

Martegani, Paolo:
Digital design : new frontiers for the objects / Paolo Martegani/Riccardo Montenegro. [Transl. into Engl.: Darragh Henegan]. - Basel ; Boston ; Berlin : Birkhäuser, 2000
 Einheitssacht.: Design digitale <dt.>
 ISBN 3-7643-6296-0

Original edition:
Design digitale (Universale di Architettura 93, collana fondata da Bruno Zevi; La Rivoluzione Informatica, sezione a cura di Antonino Saggio).
© 2001 Testo & Immagine, Turin

© 2000 Birkhäuser – Publishers for Architecture, P.O. Box 133, CH-4010 Basel, Switzerland.
Printed on acid-free paper produced of chlorine-free pulp. TCF ∞
Printed in Italy
ISBN 3-7643-6296-0

9 8 7 6 5 4 3 2 1

SOMMARIO

The authors wish to thank the designers and manufacturers who so kindly supplied images and information on the objects illustrated.

Preface

The computer revolution as it applies to industrial design is not only changing interpersonal relationships, residential spaces, the functions of objects, and the materials and processes by which things are made; it is profoundly changing even the way in which utility is conceived, along with the design methodology and practice that these spaces and these objects imply. It is not by chance that the designer of today is a much more important and visible figure than once upon a time. The tendency was once to diminish the designer with respect to the architect, who was considered more decisive and incisive from both artistic and professional points of view. The proliferation of objects – ours could well be defined as the civilisation of objects – and their influence on daily life through the new and multiple functions they express is, at least for the moment, a headlong process even though for new generations it may be difficult to imagine that only a few decades ago the world was very different and, in a certain sense, emptier: no computers, no Internet, no TV, no VCRs, no CDs, no cell-phones and the list goes on.

Domestic environments, offices, the very bodies of people themselves, have been gradually immersed in a huge quantity of new objects that designers have had to invent totally from scratch. They feel the need to extricate themselves from the practical heritage of a past already revisited too often, and from a modernity more and more projected into the future. This process obviously involves ordinary things, simpler and less technological things that have begun to shed their old skins in a context that does not seem to exclude any aspect of daily life.

In the first part of this book Paolo Martegani offers the reader a sample of new objects and new functions, outlining a sufficiently broad picture (without claiming it to be complete) of the transformations in progress and the possible directions in which the living space and its objects are going.

Thanks to new technologies, designers seem to have finally overcome that state of subjection, and perhaps of cultural

inadequacy, whose origins date back to the industrial revolution, to machines whose design seemed to leave no space for a freedom of expression equal to that achieved in other areas – for example, furniture design. Junctions, connections, and materials believed to be unaesthetic (and dangerous) were boxed in and hidden from view, transmitting to their users a functional insecurity and aesthetic awkwardness which made many of these objects difficult to use and insert into the domestic environment, where they ended up being considered foreign objects.

Today this is no longer true. The pleasant lines, variety of colours, functional simplicity, anthropomorphic shapes and pleasant tactile surfaces of many synthetic materials have all combined to establish a new relationship with objects – the external sign of a much deeper change that is radically transforming industrial design and design in general. A new aesthetic concept is being defined which, although it is only beginning, appears to be more and more widespread and recognisable; what we call digital design, i.e. one aided by that formidable tool of the computer. After years of indifference, we seem to have got over our suspicion of computers, thanks to the availability of software that is more and more malleable, powerful and, above all, conceived as the extension of the impulses of our own brains.

How this new design approach is conceived and whether and how much computers might be able to influence the creative process has not yet been sufficiently investigated.

In the second part of this book, Riccardo Montenegro attempts to reply to some of these questions as he looks into the aesthetic and practical models of the generation that created the personal computer (and its software) and into the main functions that allow for the virtual manipulation of an image.

Relating several linguistic constants found in the analysis of many of the objects designed in recent years to what came before, it has been possible to define several formal categories, four to be exact, which may make the aesthetic panorama of these past few years less confusing, identifying a

logic in the jumble of formal and linguistic contradictions that dominates the world of design, architecture and art.

The rapid consumption of forms, the incessant succession of fashions, the mixture of diverse languages and media, the decline in the concept of style which, in order to express itself and be recognised, needs to develop in space and time, are all determined by a propensity for experimentation – and therefore for design freed from its boundaries. This is something which is more and more evident in the designer of today and to which, as we will try to demonstrate in this brief essay, the growing awareness of a broader digital description of the world around us and the daily use of the computer have contributed enormously.

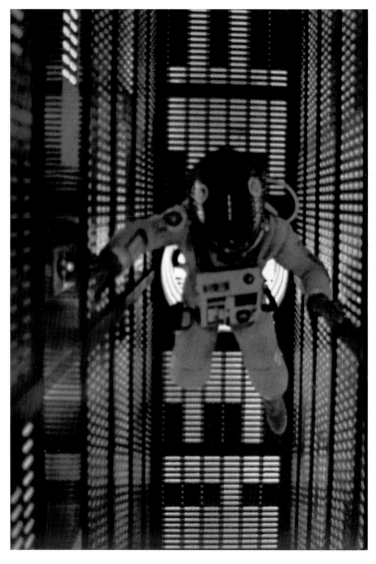

Hal 9000, *the mythical computer of Stanley Kubrick's* 2001: A Space Odyssey. *At the time the film was released, the future was imagined with computers large enough to walk inside.*

PAOLO MARTEGANI

1. The Evolutionary Function

It was with the progressive development of printed circuit boards and miniaturisation connected with the technological spin-offs from the space race that the relationship between size and form, which had always conditioned the characterisation of objects, was turned upside down. The story of this process of profound transformation began in 1971, obviously in the United States, in the laboratories of Intel with the invention of the chip, the silicon microprocessor which could alone perform the calculations of the CPU (Central Processing Unit) – the computer brain.

The speed with which the calculation capacity of the chip was to grow was defined through a sort of formula worked out by one of the founders of Intel. It was known as the (Gordon) Moore Law and said that the performance capacity of the microprocessor in relation to its price would double every eighteen months, something which has been proven a realistic prediction.

1.1 Strategic Design

The "useful form" has been one of the most used, and sometimes abused, expressions in the long discourse on industrial design dealing with the relationship between form and function. An excessively high value was definitely attributed to the latter of the two in the decades of rationalism.

Function was meant to influence the object's form. Form also theoretically influenced the optimal use of industrial resources in terms of space, equipment and personnel.

Paradoxically, it was believed that the market could be conditioned passively. On the contrary, reacting dynamically and often unpredictably, it imposed choices that privilege a series of other additional values which must, in some way, be integrated with function.

In this way, design has gradually become strategic. It is no

longer just a question of form and function. Linked to the market, company image and promotional campaigns, it avails itself of the new communication media, enters into the virtual exhibition circuit and is distributed by means of electronic commerce.

In the field of the printed word, it has become a reference point in terms of number, variety and impact of the scientific and technical journals dedicated to this theme.

1.2 The Software Product

The concept of product design has also, in its turn, gone through transformations: from material it also becomes immaterial. This is extended to software and the interface with the machine. The tasks of the designer have increased, requiring a high commitment to resolving the problems posed by the growing, cumbersome and at times annoying quantity of "objects", newly conceived and mysterious in function. The fact that we are surrounded and enveloped by them in our daily lives creates a vague sense of unease. The designer is asked to help establish a relationship of trust with these things, or at least with the portion of them with which it is possible to interact: switches, buttons and, especially, screens. These, in fact, are a sort of key; using them makes it possible to enter a broader and more complex space/time dimension.

Indeed, for a long time now, no one has been surprised or worried by what happens when utilising the commands on a telephone receiver while listening to the voice of a person who is perhaps speaking from another continent. The same must happen in terms of the other possible and ever more amazing functions and applications of electronic devices.

The careful design of the screen, the diaphragm that places itself between the user and the processor (or the network of processors) capable of providing a service, is a new and important task for the designer. The screen, its accessories, its commands and its modes of use are the last semi-material frontier – the key to entering and navigating within an immaterial world up to now explored and travelled only to a limited extent.

In this relatively new activity, several applications linked with

entertainment may strike the designer's imagination. In fact, precisely for their fantasy content, freed from the narrow bonds of reality, games in general have always represented a sector in which to explore new possibilities. This interest extends from the screen outward to the external commands. The joystick, born with the advent of electronic toys, has long since been replaced by complicated command consoles where, while the focus is only imagination, the ergonomic aspect has not been forgotten.

At the same time it may seem surprising that the glasses, helmets and gloves associated with virtual reality have not undergone the development that one would logically have expected. On the contrary, virtual characters make up a context in which there is a great deal of movement: heroes, but more often heroines, seductresses and now even top models in demand by the most important agencies in the world, living an imaginary life somewhere between the Internet and video games.

1.3 From the Object to the Process

Not only is design changing but, as a consequence of computer technology, the entire process of invention and production as well. Changes are happening; sometimes profound transformations, from advertising to distribution, and even assistance and re-cycling.

On the production front, computers have accelerated the process of automation. The means by which it continues on its course fall into two categories. On the one hand, we have robots which permit the replacement of human workers on alienating assembly lines, something which creates many social issues. On the other, we have the capillary diffusion of extremely efficient numerical control machines. In fact, in industry today, respect for production specifications, along with quality standards and demanding competition, have imposed a need for precision that only a computerised system could offer.

In the various areas of production, service companies abound in all shapes and sizes, offering to transfer their know-how to the many and variegated applications both of numerical con-

MINIATURISATION

The history of the chip – the silicon microprocessor that started the computer revolution and miniaturisation. It all began in 1971 at Intel laboratories.

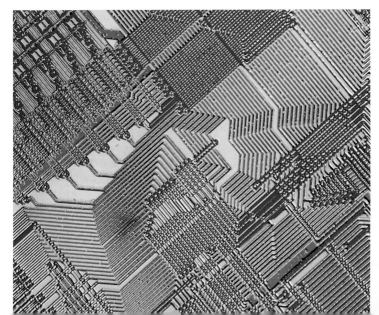

Front page: above, chip for the Synertek computer (© C. Chuck O'Rear/Grazia Neri). Below: close-up microphotograph of the surface of a printed circuit board (© C. Scienze Photo Library / Grazia Neri). This page: above left, the Sony walkman in the version for outdoor use; above right, Activ, portable audio with anti-shock device, by Philips; right, Cpen Scanner by Globaltech, design, C. Technologies. Its small size and light weight make it easy to handle.

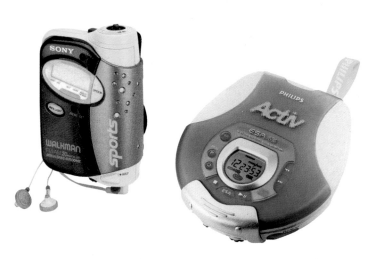

trol as well as industrial automation in the broadest sense of the word, proposing the most suitable solution on a case-by-case basis, supplying the hardware and software necessary and intervening even in the training and updating of technical personnel.

One of the steps forward that is happening on the production front is also happening on other fronts, though in a different way. Computers condition the entire idea-to-consumer cycle. Just think of how the means of advertising a company's image and products have changed with the Internet and how extensive their distribution network is as a result of e-commerce.

1.4 Parallel Fields

There are also other fields of study presenting parallel problems of creativity for the designer. Cinema and television are definitely among these. Special effects have drawn deeply from computer technology while in many other respects they have anticipated trends and at times forewarned of the transformations we are now experiencing. The functioning beings in Ridley Scott's disquieting *Blade Runner* are so similar to their homologous living beings as to become practically indistinguishable from them. And the evolution of mechanical dolls and animals is speeding in that direction.

The rounded shapes of the objects and environments in
8 Stanley Kubrick's extraordinary adventure *2001: A Space Odyssey* were undoubtedly a major precursor of today's tastes. In stark contrast to the monolith, the habitat of the interior of the space station, populated by Airborn armchairs designed by Werner Pantom, as well as that of the space craft, are characterised by fluid, enveloping, continuous forms. But the prediction does not end with the environments and objects in them. It also takes in the typically "digital" aspect of the displays of the flight and control instruments.

Architecture and, therefore, design can be observed and theorised through film, new media, video and animation, as at the University of Florence, which has created the International Festival of Architecture in Video. This is a recurring event where a vision of the future of design is presented through the

exploration of digital technologies in the building of architecture, compared with the role that architecture plays in cinema, as in the specific case of the work of director David Cronenberg.

1.5 Multimedia and the Object

Practically all objects are becoming multimedia oriented. Up until a few years ago, the function carried out or the message emitted by objects normally made use of a single means: text, audio, graphics or movement. There have always been attempts at combining two or more of these, and some important results have been obtained. For example, television has placed image, audio and movement in a single medium, understood as a means of communication. But the aim of unifying all media has only been fully achieved with the development of the computer.

In fact, digital technology based on the bit, that elemental portion of information, offers a new "format" in which it becomes possible to translate all types of messages: drawings, photographic images, video, speech, music and much more. A sort of Esperanto that allows for the unification of all the many expressive means through a single code. "Information technology dematerialises a large part of what it touches and consumes little material and little energy" (John Thackara). The result is the reduction, or even the disappearance, of the emphasis on some parts of mono-media objects, like the "horn" of the old wind-up gramophone or the importance of the casings of stereo equipment. The co-existence of two or more means of expression, on the other hand, gives an action – communication in particular – its multimedia attribute.

The multimedia concept, seen as the use of various mediums to emit a complex message or to carry out a highly articulated action, is extended to all categories of objects. And this is the typical functional feature of the design of the things which surround us. All objects/instruments perform a multitude of functions and are now in some way aspecific or multi-purpose, at times in such a rich and complex way as to surprise, intrigue and even disturb.

NEW APPLICATIONS

The concept of product design is going through many transformations: the immaterial also comes from the material. Using the commands of various electronic devices, more and more amazing functions are activated and new applications tested.

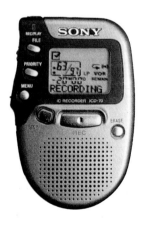

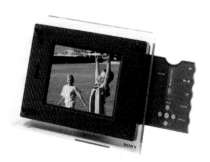

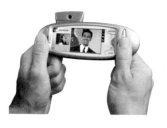

Front page: top, design of a printed circuit for a microchip (© C. Scienze Photo Library / Grazia Neri); below left, diary, phone book, watch/alarm, all incorporated into the Electronic Organiser; right, even the photo frame has evolved: the PDH-A55 *by Sony: image-viewer, photo/movement, sound track and slide show. This page: top, digital recorders automatically transform words into text available for processing on a computer; below, the telephone now offers Internet access, sending and receiving short films and arranging teleconferences; here seen with Nokia monitor.*

Objects for communications, in particular, present problems that go beyond traditional ergonomic ones, and look to aspects that tend to widen the range of sensorial activities involved in the process of communication. The function of these objects is more and more often to integrate speech with a soundtrack or image, which in turn becomes coloured, dynamic, complex and, most importantly, interactive with the user. This user becomes less and less the passive recipient of the action or message and takes on more and more the role of a protagonist who acts, selects, conditions and processes the message in time, modes and content.

Communication itself, however, multiplies its own modes, means and ends. While, on the one hand, the sources are multiplying along with the frequency with which all types of information is emitted – press releases, news bulletins, advertising – on the other hand, the need is growing for more inter-personal contact, underlining the opportunity to monitor on-going processes and evolving situations. Consequently, numerous and different tools for reception and transmission must be made available. These start out characterised by one specific function, but then immediately afterwards begin a transformation that makes them or tends to make them suitable for many purposes – multi-purpose and multimedia.

The transformation in progress is multi-faceted and has many fields of experimentation and application; among these is the very appealing sector of architecture. The intelligent building can be seen as a process which applies the resources of technological progress to the optimisation of the conditions of comfort and economy of management. Initially referring to constructions destined for production or, in any case, for specific uses, new applications are also being found in the context of the domestic habitat.

Many studies have come out on the electronic house. Since the mid-1990s, as part of the fundamental programmes of the Netherlands Design Institute, *The Doors of Perception* has been dealing with the design challenge of an interactive multimedia approach in social and cultural contexts. This was followed by *Doors 2*, whose principal theme was the design con-

text of the "home". This is understood as comprehending space, site, idea, experience and memory. The declared objective involved architects with designers in the design of electronic "homes", planning a technological community.

The manifestation of new ideas in American design and architectural practice has, moreover, been embraced as a current theme by prestigious institutions such as MoMA, which has proposed *The Un-Private House*. This exhibition highlights new requirements which are reflected in the more and more changeable role of the private residence. A presentation of many designs prepared in the 1990s, some built and some which remained proposals, expressed the life-style defined in the domestic space; the way of working or of utilising free time, but above all the ever-present preponderance of new technology in the life of the house. Among the noted contributors to the exhibition were Herzog and DeMeuron, Tschumi, Koolhaas, Holl, Hanrahan and Meyers.

While the creativity of architects plays a guiding role in the context of space, some changes in the world of production have definitely made an impact as well. Miniaturisation has permitted a substantial leap in quality in terms of the physical size of objects, making them portable. This characteristic is taking on increasingly interesting connotations. Early successes, a few years ago now, included radio and stereos. How can we forget the Sony Walkman, which accompanied the joggers of a generation. Later it was wristwatches that drew attention with their intrinsic portability, pointing the way to the many functions that would be added to that of telling time; they have become data banks for telephone numbers, step-counters for walkers; they have sophisticated built-in instruments like thermometers, altimeters, barometers, and are specialised for various sports like scuba-diving and hiking. They have also tried to replace the diary but the very small size presented an insurmountable problem, a situation which brought about the diffusion of electronic diaries, leading up to the digital assistant. But these are objects which are rapidly becoming obsolete as a result of the quick, unstoppable assertion of the portable multimedia object par excellence: the cellular

20

The designer is interested in the creation of the physical object (industrial) and in the design of the interface (visual), understood as the assembly of texts, drawings, graphics and commands through which the user dialogues and interacts with the computer present in the object and with the network of which it is one of the terminals.

Top: in the early 1990s the DA, Domus Academy, had already begun a course updating designers on the evolution and integration of new technologies: Design of the Interface: the design of interactive communication. *Bottom: the International Festival of Architecture in Video, Florence, explores the use of digital technologies in the relationship between architecture and cinema: a sample image taken from the work of film director David Cronenberg.*

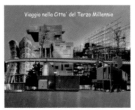

Top: The Smiling Room, *intrusive communication, in one of the studies by archi-tect Maurizio Pascucci on the synthesis between form and image, between reality and simulation. Bottom: architecture and urban space reinterpreted and represented on the monitor with animation and virtual reality techniques.* CD-ROM Journey in the City of the Third Millennium, *by LaMA, Laboratorio Multimediale di Architettura, University of Rome "La Sapienza".*

phone, indisputable protagonist on the communication and multimedia scene. (Obviously, we are ignoring devices like the pacemaker, hearing aids and other brilliant applications of medical micro-electronics.)

Multimedia features thus profoundly influence design, production, and even our entire existence. By now almost all objects, in a more or less accentuated way, are involved in this transformation process, which uses their complexity by means of the requirement of multimedia. This is, in any case, a determining factor in the objects and instruments found within the context of communications. It strongly permeates the context of the electronic residence; what could be called "domotics", a term made of the Latin root "domus" for the inhabited construction, with its suffix drawn from "robotics" and "informatics". Finally, some objects have become wearable multimedia prostheses, accessories or appendages, and in some cases even bionic off-shoots. Using this outline, we will take a brief but, we hope, evocative journey in the following pages through the rapid transformation process now underway and attempt to identify its lines of development.

2. Multimedia Objects

In terms of the multimedia aspect of the objects analysed, any attempt to group them into one category seems forced. If we have done so, it is simply for the sake of clarity. Therefore, it should be pointed out that gathered in this first category are those objects which have no predominant function that might place them in one of the other following categories. Practically speaking, we are analysing those multimedia objects here that neither have any relation to either communication or control, nor are they household appliances or other domestic apparatuses, and they have no particular portable characteristics.

24-25 2.1 The Robot

The ancient dream of the animated object, preferably in human form, is becoming a reality, thanks to computer tech-

nologies. The use of this type of object was first developed for military and industrial applications, and then those aimed at exploring inaccessible places. Later, with adaptations and modifications, the robot invaded the field of training and self-study, especially in languages. The frontiers of its use have been extended into many environments, from rehabilitative gymnastics to assistance for the disabled. At the same time, with the reduction in the connotation of usefulness and the increase in communication with the user, a link has been forged with the entertainment sector. Precisely because it is not so heavily conditioned by practical aims and is open to fantasy, this sector is of great interest.

The many types of these objects, the extension of their fields of application, the proliferation of methods of application, all the reciprocal interactions, and especially the connection of these within networks, has become a phenomenon so important as to indicate almost the need for a new discipline.

2.2 Ubiquitous Computing

This expression is related to "distributed computing" and indicates the set of objects, behaviour and phenomena associated with it. A significant contribution has been made in this field through the research of the team directed by Mark Weiser at Xerox Park in Palo Alto. In the same way as happened with electricity, initially highly concentrated in its use and later widely diffused in thousands of devices, scholars held that the same thing would happen with computer technology.

The current situation shows how correct that prediction was. In fact, a great variety of devices are gradually being developed alongside the computer, which in itself contains all calculation functions. These devices are almost always lightweight, compact, often portable or mobile, sometimes even blending into the environment. All of them, in any case, are characterised by the indispensable presence of the mythical "chip".

2.3 Digital Processing

As a result of computer technology, entire families of old, traditional objects are being changed and enhanced. One exam-

ROBOT

The age-old dream of the animated object, all the better if anthropomor-phic, is becoming a reality thanks to computer technology.

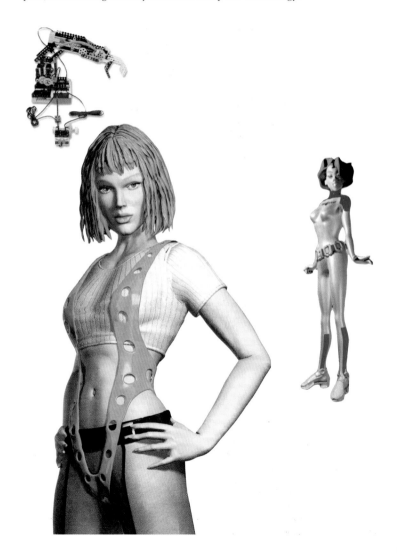

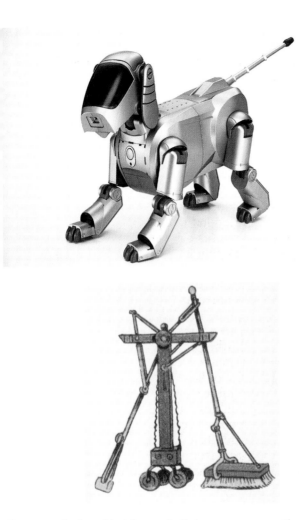

Front page: the Lego block has gradually become more versatile. Now with the "smart" components of Robotics Intention System, it can be used to construct a robot. Bottom: the dog Aibo by Sony is a companion robot. Through the application of artificial intelligence, he simulates the behaviour of a living animal. This page: top, Avatar, virtual characters, heroes, but more often heroines, living an imaginary life somewhere between Internet and video games. Bottom: in 1899 Jean Marc Côté made a series of prophetic drawings of life in the year 2000, included in Isaac Asimov's Nostalgia for the Future.

ple is that of a small object: the Lego block. Its form has not been changed since it was created in Denmark in 1934, nor has its linking system. But it has continuously improved its versatility in allowing the construction of houses, automobiles and, later, space stations. Now its components, with the new "intelligent " Robotics Intention System, can be used to construct a robot: a PC-supported operation with instructions on a CD-ROM, based on inserting one element into another, with the addition of motors, touch and light sensors, for manual command by means of impulses and infrared beams. Lego has obtained these results through profitable collaboration with MIT. If such a prestigious scientific institution has dedicated a portion of its activity to this application, then it must believe that development in this sector goes well beyond the sphere of play. In fact, the applications are very varied and give the chance to develop individual creativity, substantially exercising the imagination. Further developments are being studied, focusing not only on technological evolution, but also on social aspects, with the establishment already in progress of Lego Mindstorm Centres.

2.4 Artificial Animals

The dog christened Aibo, a pet robot put into production by Sony in 1999, immediately recalls the mechanical pseudo-living beings in the cult film *Blade Runner*, so similar as to be indistinguishable from the real thing. Although the Sony product looks like a dog, he could fool no one. He is a toy, but not necessarily just for kids; an imitation of a natural form that, thanks to the combined use of artificial forms of intelligence, simulates the behaviour of a living animal – an automaton which establishes a relationship. He is a bit less demanding than the famous "Tamagotchi" that, with its need for food, cleaning, cuddles and all the rest, distressed many young people both in Japan and elsewhere. But even Aibo involves the user on an emotional level. He barks if you don't pay attention to him and, consequently, stimulates interaction. Alongside the classic achievements they have made in the areas of listening and viewing, the Japanese house now

inaugurates a new sector in domestic entertainment with this product. And the choice of a dog – the pet par excellence – definitely makes it a more reassuring product.

How does it work? A software kit enables the user to imagine, plan and command by remote control the robot's personalised movements and behaviour. The robot is, in fact, equipped with a network of receptors that make up a sensor system. The automaton is able to mime the movements of a real dog. He learns progressively and can be customised to the extent that he responds only to the orders of his owner, or should we say his master.

He is sold over the Net only in Japan and the US. With this system of distribution, the company intends to establish a direct relationship with its customers. Though a little overdone, Aibo seems almost to initiate a process of transformation which could drive the artificial mechanism towards more evolved forms fusing automation, artificial intelligence and self-teaching processes.

3. Multimedia Objects for Communication

The communications sector, both interpersonal and mass communication (broadcast programmes, signs, information systems etc.), as well as that of control devices, is undoubtedly where multimedia is spreading most intensely.

Telephones, fixed and mobile, are leading this development, but radio, television and the Internet are no less important. The main areas are those concerning the guidance and control of land vehicles and air and water craft. What is happening in the field of diagnostics and clinical monitoring is equally significant.

3.1 Designing the Interface

Multimedia equipment used in communication, independent of its physical size, whether portable computers, weather centres, or POIs (Points of Information), today appears increasingly easy to use. If communicating with them is becoming eas-

COMMUNICATION

The sector of communications, both interpersonal as well as on a mass scale (broadcast, signage, information systems), and that of control devices, are undoubtedly the area where multimedia is spreading most intensely.

Front page: top, Jubilo, *a digital guide with dates, places and events for every day of the Jubilee, as well as a selection of sacred texts and prayers in five languages. Produced by MAC s.r.l., designer Giovanna Talocci; bottom left, portable DVD reader by Sharp. The new Video Disk readers are becoming more and more popular because of their high-quality images; bottom right, the virtual screen by Siemens. Among other communication-oriented objects, information points are taking on a highly distinctive physiognomy. This page: top left, the presence of the monitor, reduced in size by the use of the cathode-ray tube, is being multiplying everywhere (Brillance © 151Ax Philips); bottom, digital cameras by Sony and Nikon. The digital photograph, because it can be transmitted over the Internet, is changing ways of communicating.*

ier and easier, this is due to intensive development which has involved (and involves) the designer in at least two points. The first is the design of the physical object (industrial). The second is the design of the interface (visual) which includes the texts, drawings, graphic layouts and commands through which the user communicates and interacts with the computer and the network of which it is only one of many terminals.

Referring to problems connected with the early attempts at designing Points of Information, Franco Maria Rao, designer for Gruppo Space Planners, notes:

> In rapidly communicating information of an operational nature, like timetables, road conditions, stock market quotes or weather forecasts, and of a commercial/cultural and advertising nature, our task was to "clothe" the hardware. Taking a computer and a monitor, putting them in the middle of a street and making them work correctly was an extremely stimulating challenge. In order to function optimally a computer must operate in a clean, dust-free, relatively cool environment not subject to sharp rises in temperature. On the contrary, we found ourselves having to leave one operating 24 hours a day – the same situation in Bolzano (extreme northern Italy) on the 25th of December as in Messina (extreme southern Italy) on the 15th of August. Moreover, we had one or more monitors operating in full daylight. So our job as tailors for the computer's "clothes" was more complex than we had expected. We had to combine design, engineering and technology and did a lot of experimenting […] innovations in the field followed rapidly; interactivity, the touch screen, video disks, dedicated printers, magnetic cards, all these modified our "clothes" and increased the complexity and problems of our designs.

Among the Italian institutions which have traditionally conducted important studies and research into the "visual" context is the DA, Domus Academy, which, in the early 1990s, with funding from the European Community, began a training course to update designers in terms of these advances and their integration with the designer's activities. The theme was **20-21** recognisable in the title of the course: *Design of the Interface: the planning of interactive communications*; formative training

to link the implications of the innovations in computer technology to traditional design practice; design focused on the technical aspects related to the creation of interactive systems. Many topics were discussed, ranging from hypertext and hypermedia systems programming to electronic imaging and the principles of user interaction, from the impact on various landscapes of interactive objects to marketing.

3.2 Guidance, Monitoring, Checking

In the area of public and private transport, it is almost impossible to find an aspect in which some computerised device is not present with an ever more important role – sometimes even a key function.

The concept of multimedia has been fundamental in aeroplanes for decades. Previously this was mostly true for the cockpit where a vast range of instrumentation covered all available surfaces. It has now invaded the passenger area. First with screens and monitors giving flight information, more recently giving each seat a console in the armrest which the traveller can use to select programmes from an assortment of films, games, and various types of information.

On ships, the compass has been surpassed by satellite equipment. This has improved the quality of information well beyond the numbers related to latitude and longitude. A device called the GPS, General Position System, now supplies the geography of the surrounding site on the screen: the position of the craft, course direction and information on miles travelled and how many are still to go, average and current speed, fuel consumption, and so on.

On-board instruments, even on leisure boats, are becoming more and more sophisticated and can guarantee constant and detailed monitoring of weather and climate conditions, engine efficiency and structural conditions of the boat. Practically without limits and, obviously, with communication delivered in very appealing forms: multi-coloured, back-lit, high-resolution plasma screens, animated by moving images and accompanied by attractive sound effects.

The automobile is also becoming a computer on four wheels.

GUIDANCE

Multimedia instrumentation is becoming increasingly widespread in functions connected with the guidance and general control of all types of land, air or sea vehicles.

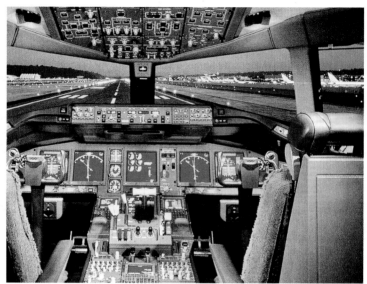

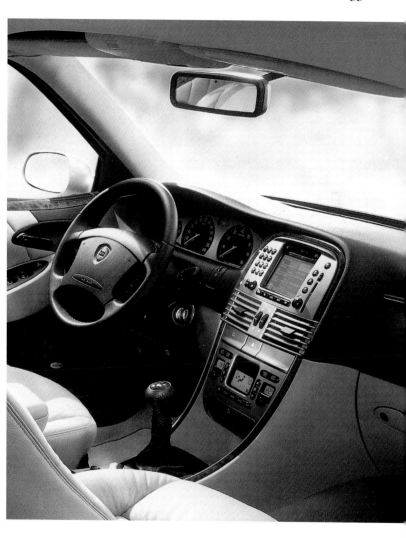

Front page: top, the multimedia aspect in aeroplanes, initially concentrated in the cockpit, has now extended to the passenger area; bottom, Sony GPS. On-board ships navigation has gradually left the compass behind and turned to the assistance of satellite devices. This page: the control panel on the drivers side of a Lancia Lybra. The car is becoming a computer on four wheels.

Engine, air-conditioning, road and braking performance are now all controlled electronically. Bosch is planning the *Cockpit Management and Data System* – a console incorporating a radio, CD player, mobile phone, TV and satellite navigator – for the near future. *Parktronic* is experimenting a series of radar sensors for Mercedes that check constantly for the presence of obstacles as well as the distance between you and the vehicle in front of you. *Telematics*, BMW, focuses on traffic information and hotel availability in the area. Finally, the Internet is becoming available in your automobile.

The future is science fiction, with the possibility of driving your car with voice commands or seeing through fog with the help of infrared beams. *Night Vision* is a device developed by General Motors in collaboration with Rayteon System which projects images onto the driver's windscreen of the silhouettes of the objects/obstacles present in the street and records them on video, even in the worst weather conditions.

4. Multimedia Objects in Home Design

"Joe's Law" is ironic and formalises the trend to connect to the Internet using any device other than a computer. Bill Joe is one of the founders of the California company SUN. According to his theory, when the computer meets the Net it is divided into a lot of intelligent splinters which adapt in an optimal way to the network's centre-less logic, one of the characteristics of widespread information technologies (see Ubiquitous computing). "Jeanie", software that allows any device equipped with a program to be networked, is the point of departure that the company is establishing in experimenting with a completely interconnected house.

The challenge of the smart house has been on for some time now. A fundamental step was the recent definition of WRAP (Web Ready Appliances Protocols). Ariston Digital has been heavily committed to this operation through a research project involving the laboratories of several European countries. The **40** result at this point is *Leon@rdo*, a control centre touch-screen

monitor for all appliances connected to the Internet. The firm has been developing its research in this promising sector for decades now through the evolution of Arision, the electronic butler. Today Ariston is collaborating with Microsoft in using Windows CE, the operating system for devices other than PCs. These are devices that are beginning, although very gradually, to take a leading position alongside traditional ones. A perfect example is the satellite television set transformed into a hybrid known as TV-Web, which also connects to the Internet.

4.1 Intelligent Buildings

This is the expression which indicates the now established practice that integrates the built, understood as 'hard', with a more and more complex collection of devices and networks in order to better control environmental conditions; the building's nervous system, as it were. Initially concentrated on architectural spaces of a specialised nature, such as factories and hospitals, training and recreation facilities, attention has been increasingly focused on the domestic environment. It was inevitable that the kitchen would play the central role in this enterprise and, in fact, of all domestic spaces, it is the one which has undergone the most profound transformation.

A fundamental passage in this transformation can be seen at the end of the 1920s with the widespread introduction into residential housing of research results on the organisation of spaces, furniture and tools; a process that was recognisable in the *Frankfurt Kitchen*.

It is not easy to identify a precise date for domestic automation. It should, therefore, be considered a gradual process. Some scholars even feel that the joining of architecture and automation began with the integration of electricity. Stefano Casciani, in his essay *Electric Dreams* maintains:

There is no exact date when modern architecture met electricity. But it could be estimated as 1877 when, two years before inventing the incandescent light bulb, Thomas Alva Edison carried out his experiment of electrically illuminating New York City. After this historic appearance of light "on command" in the city that stood as a symbol

CONTROL

Multimedia control devices are proliferating in various fields of application, and are increasing the quality and quantity of the information they collect, process and communicate. Special developments are connected to clinical diagnosis and monitoring.

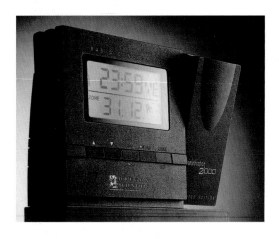

Top: the radio/alarm clock by Oregon Scientific – the Celebration 2000 – *has a very appealing design. Bottom: the* Qubo Minidisk *by Sony. The overall quality of all audio devices has improved considerably, thanks to digital technologies. Front page: top,* Dreamcast, *the video game console by Sega, leader in an ever-expanding sector; bottom,* Tomey 670 Perimeter, *oculist's instrument produced by Insight, Inc., designer Bryan Hotaling (photo Steve Robb).*

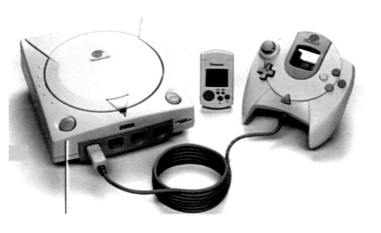

of universal progress, the dates and events followed frenetically. In 1886 the first household appliance appeared, the cooker or stove, designed for the kitchen environment that would for many years be the principal laboratory for technological innovation in the home.

In the early decades of the twentieth century, there were great utopian designs for the future of humanity, among them Italian Futurism. In 1930 the Gruppo 7 architects – Figini, Pollini, Frette, Libera – in collaboration with Pietro Bottoni and sponsored by the Edison Corporation, presented the *Electric House* at the Villa Reale in Monza. Another leg of this developmental journey can be identified in the *Dymaxion House*, which represents the conclusion of the studies and experiments by R.B. Fuller in this area. Later, after the War, the 1960s saw the Amazing Archigram create the foundations for the development of a new environmental utopia.

Then it was the development of television that brought its influence to domestic spaces. At the 1983 Milan Trade Fair, architect Ugo La Pietra set up a house loaded with electric appliances and video screens. "What I want to show is not only the house of the future but a house where computers and communications triumph." In fact, this prototype of a computerised house presented more or less traditional spaces transformed by the presence of video terminals inserted everywhere.

Information technologies, with all their derivations and, in particular, remote control, are therefore increasingly present, to the point of assuming a front-line position, if not exactly in the buildings being built, at least in the plans and theories of future spaces.

4.2 High Tech Habitat

These are the roots of one of the most diffuse residential styles today. Clino Trini Castelli, in his *The States of Domesticity,* names it and defines it:

High Tech, New Tech. Born out of the radical, industrial Anglo-Saxon architectural culture of the 1960s and 70s, it has revealed, time

and again, its interest in metals and an increasingly differentiated utilisation of materials. It is an interactive style based on the use of highly manipulated technological structures. It is directed at a young, cultivated and dynamic audience, always up-to-date on new trends in industry and technology. Hyper-formal and developed on an international level, its atmosphere is minimal and carefully calibrated, where basic and dynamic elements co-exist.

The liberated and redesigned spaces in both domestic and specialised contexts have constituted a phenomenon of transformation which sociologists are observing with great interest. One that, however, was preceded, accompanied and, sometimes pioneered by the industrial world. The large multinational companies of both the West and the Pacific Rim would challenge one another on this terrain.

A change in strategy should at any rate be noted in the fact that initially the entire house was proposed while later it was single spaces, finally giving precedence to single objects. In practice, there has been a shift from the event to the process, operating first in those spatial contexts where the assertion of the new met the least resistance.

4.3 Home Theatre

The television, although also involved in transformation processes tending towards the digital and high-definition, has been replaced by the Home Theatre concept: installations that utilise big-screen projectors that reproduce the atmosphere of the cinema in the living room. SIM2 Multimedia is an Italian firm in Pordenone competing for leadership in this sector, planning future uses for cathode-ray tubes. Strong interest in the United States has brought about a joint-venture called SIM2 Seleco USA.

The home entertainment market is also growing rapidly in Europe as a result of the strong impetus created by the ever-widening availability of audio-visual material aired by satellite channels, whether analogue or digital, open or encrypted. At the same time, the proliferation of DVDs (Digital Video Disks), of a much higher quality than the "old" VHS cas-

DOMESTIC DESIGN

The challenge of the "smart house" has been around for a long time now. One fundamental step was the recent development of the protocols and software that make it possible to connect any device into a network: the basis for the completely integrated house.

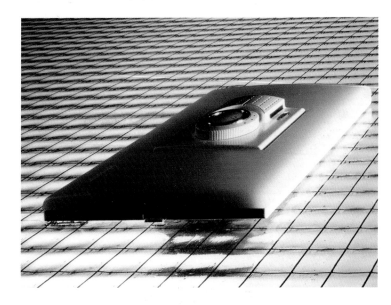

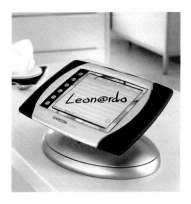

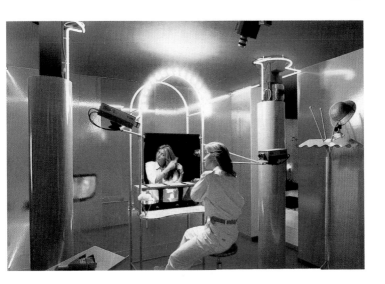

Front page: top; the BTicino light switch, the "fruit of plant design becomes multi-functional and its appearence is formally enhanced and differentiated"; center, Leon@rdo by Ariston, a firm that has for decades been developing systems for the management and integrated control of appliances and installations in the domestic environment. This page: top, Telematic House. *In 1983 architect Ugo La Pietra set up a house loaded with appliances and video screens for the Milan Trade Fair. Bottom: the* Wired House *by Araka and Madeline Gins; diagram of the deconstruction of a domestic space.*

settes, along with the development of Pay TV, are stimulating the diffusion of projection equipment for collective or home use. The video-wall is already a presence in the domestic habitat, representing a high-impact status symbol.

4.4 The Interactive Environment

What happens when what is meant by multimedia for individual objects is applied to an entire space? This topical and innovative theme has not yet seen the identification of any established trends, as can be noted when analysing the experimental proposals advanced by Philips, a firm particularly active in this area. In 1995, together with DA, Philips presented the results of a theoretical study: *The Solid Side of a Changing World – Designs and Proposals*.

One year later, it displayed its project *Vision of the Future* at its Eindhoven Holland headquarters: sixty objects, not commercially produced, experimental prototypes of objects or services that attempted to wed existing technology with the needs of a changing society. Different professional fields were called upon simultaneously: from sociology to communication, mechanics to information technology. The observation came from this experience that the presence of these new objects can have an important impact on the physical space of the residence: windows that turn into screens, distribution points that can be modified, encumbrances that disappear, etc. What followed were proposals for multimedia furniture, among them *Plugged Furniture*, a project run in collaboration with the Dutch furniture company Leolux, in which several pieces of multimedia furniture were presented. Among these the most significant was the "wall", an element with the capacity to rotate 360°, equipped with audio-visual devices, which combines spatial flexibility with multimedia. It was, however, heavy and complex and rather difficult to use as a result of its size and low adaptability over time owing to the excessive specialisation of the equipment housings (monitor and recorders, and the support materials such as CDs and cassettes). This size and weight was not compatible with the rapid evolution of these objects and was an inconvenience

that Philips overcame in 1999 with the presentation of its own collection of intelligent objects.

This collection, under the title *The Near Future House*, proposed splitting the multimedia component into many small autonomous elements that, just by means of their simultaneous presence, transform the living conditions of the domestic habitat. Though the products proposed look like familiar objects, they incorporate the most advanced technologies and offer the user greater flexibility with their capacity to understand, anticipate and satisfy needs.

4.5 The Metamorphosis of Light

Artemide is one of the most important manufacturers investing heavily in the study and experimentation in the new potentials for light. In an interesting exhibition at the Triennial Palace in Milan in 1999, this company posed some questions and offered some answers.

> How much do new technologies lead us to modify our relationship with light in space? And, above all, how is light responding to the growing complexities of the scenarios and new behavioural models of the third millennium? The space of the future will be intelligent, technologically advanced, designed to be managed by means of interactive and multimedia lighting systems capable of establishing new relationships between humans, light and objects.

So read the inaugural manifesto, which concluded with "Light will, therefore, be multi-modal, interactive and intelligent".

An applied example of these statements is seen in the *Metamorphosis* lamp, an innovative device illustrated effectively by a CD which takes the observer, who has a wide range of possibilities for interaction, along the course of development by top designers in collaboration with the firm in its creation. In a gallery of high-quality images, the CD illustrates the company's history, research and production. Above all, it invites the viewer on a light-trip. At the end, it simulates the features of this new concept in lighting on the monitor: *Metamorphosis* – the light that changes light.

THE INTERACTIVE ENVIRONMENT

What happens when the concept of multimedia passes from objects to the entire space ? A topical and innovative theme. There are many experimental proposals, Philips and Artemide are particularly active in the sector.

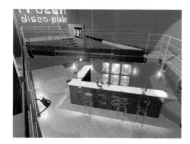

Top: Frozen Bar, *digital elaboration of the design (M. Bredice, F. Cassone) of a theme-bar characterised by multimedia devices. Center: the* Metamorphosis Lamp *by Artemide, a new concept in light allowing the choice of colour and intensity. Various designers worked on developing this lamp. Aldo Rossi's version in the illustration. Bottom: one of the environments in the exhibition* The Form of Light *presented by Artemide at the Milan Triennial. Light – multi-modal, interactive and intelligent. Next page: top, the* Smart Bathroom, *design by Matteo Thun for Electronic Environment. Bottom: Lisbon Expo 98, US and French Pavilions. International expositions are an occasion to verify the rapid development of multimedia.*

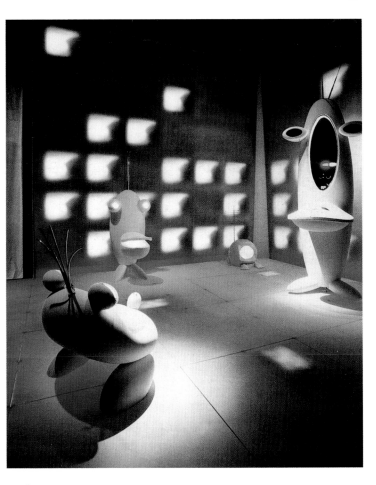

A product that, without losing the advantages of automated production, allows for a high degree of personalisation. Technically the device is based on three parabolic reflectors that project the light produced by the same number of halogen bulbs through diachroid filters in the primary colours red, blue and yellow, producing a monochromatic swath of light outlined in different-coloured haloes. Intensity is remote-controlled, allowing for an atmosphere of variable light and colour.

A personalised light-source that adapts to various environments, different activities, and changing moods.

5. Multimedia Objects to Wear

The imagination runs immediately to the wired helmet and gloves of virtual reality devices and tends to attribute the concept to science fiction. But things are not quite that way. In reality, lightness and reduced size are features that create portability. We could begin with the watch, with a series of functions in addition to telling time. Other objects normally worn or carried in a pocket are today loaded with new functions as well: a calculator that could be taken for a business card, keys that carry remote-control buttons to unlock your car, pens with tiny laser beams that point and indicate (practically an extension of the index finger).

5.1 Tools for Travelling

Already broad and varied, the family of portable objects we link with the positive connotations of travelling and adventure, which reawaken the nomad spirit in us, is utilising digital technology and multimedia to grow and evolve.

Interesting applications in this context have been studied and presented by the Domus Academy, where Marco Trimarchi and Marco Susani have set up a group to develop various objects. Among these is a special kind of wallet which becomes an element in a monetary system when inserted into an information network dealing with the circulation of our

money. Another is pocket-sized for travel on foot in the urban jungle – a public transport map that transforms into a pocket terminal capable of proposing alternative routes – a sort of pocket navigator. Then there is the translator/interpreter, intended also as a social element: a travel diary to record appointments, sketches, photographic images and sounds gathered in the course of travels and organised in multimedia pages.

These are only some examples of the applications being developed in the sector of digital micro travel objects.

5.2 Cellular vs. Computer

The cellular phone is the undisputed protagonist on the technological scene. In fact, thanks to its overwhelming diffusion on all social levels, the mobile phone's future looks very promising. It can open car doors, send and receive short films, be transformed into a TV remote control, and even has the possibility of holding tele-conferences.

One of its strongholds is located in Salo, about a hundred miles north of Helsinki, in a highly industrial spy-proof factory, where Nokia researchers study and experiment with the 3G cell-phones, the 3rd generation, intended to compete with portable computers. Their objective could be summarised in the slogan "connection always and everywhere". The cell-phone's future is believed to lie in the exchange of data and images rather than of voices.

Multinationals like Nokia, Motorola, Ericson, Philips and others have taken on a great commercial challenge in the Pocket Internet field. WAP is the acronym for the universal standard that allows cellular phones access to the information and services of the Web. Dozens of companies have collaborated on defining this standard, but at the moment the Finnish have the advantage.

However, the Japanese are hot on their heels and estimate that by the year 2001, the Internet will have arrived in the pocket of the cell-phone user. A disturbing scenario for computer producers who, within a very short time, will have to respond to an offensive by the telecommunication companies.

WEARABLE

Lightness and small size are features that create portability. Sensors integrated into personal objects capable of transmitting, receiving and processing allow interface with the near and/or remote external atmosphere in an articulated, complex and at times disturbing way.

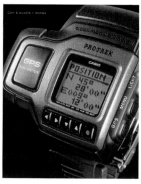

Top: wearable, liquid crystal monitor by Sony. Left: video jewellery, a micro viewer made up of connected parts that create a necklace with a very strong visual impact. Produced by Nirware Cyberdesk, design and photo Krohn. Right: Global Position System, Casio wristwatch. Miniaturisation is making more and more instruments and devices "wearable".

Personal Digital Assistant, Production Concept, designers Michael Barry, Shawn Hanna and Jay Wilson – GVO Inc. (photo GVO Inc.) A portable "desk" for taking notes, writing, communicating, anywhere and any time, even on the run.

5.3 Affectionate Computers

Currently in the experimental phase, the affectionate computer constitutes a relatively new but promising field of application, with complex psychological implications. In fact, some unusual wearable applications belong to this context. IBM has already developed the first prototypes in their Japanese laboratories, while very complex experimentation is going on at the MIT Media Lab where they are studying the possibilities of so-called "intelligent clothes": clothes equipped with sensors and, therefore, able to signal the effect on our behaviour caused by alterations in the external environment; a way to monitor our reactions, conscious or unconscious, without our knowing that it is happening.

The implications, as always, could be a nightmare – an updated and more powerful version of Orwell's "Big Brother". But on the other hand, if we take a positive attitude, they can supply us with basic indications for improving our lifestyle. They could, in fact, offer a sort of control-panel capable of giving useful and up-to-the-minute indications on the workings of that complex piece of living machinery that is ourselves.

RICCARDO MONTENEGRO

1. From the Set-square to the Bit

The material aspect is diminishing in contrast to the immaterial aspect, which is gradually intensifying.

PIET MONDRIAN, *New Art New Life. The civilisation of pure relations*, 1934

1.1 Real Sign, Virtual Sign

It has been over fifty years since the first computers were used, the ENIAC (Electronic Numerical Integrator and Computer) built by American researchers Prosper Eckert and John Mauchly in 1946, and little more than twenty years since the diffusion of the personal computer, whose debut dates back to 1979 with Steven Jobs and Stephen Wozniak's Apple II.

At this point, it might be useful to take a look at the influence digital technology has had on design and, in particular, industrial design.

The picture is clear of the process that, using digital technologies, has on the one hand radically transformed production procedures, now completely automated and/or roboticised, and on the other multiplied the functions of almost all objects, also in the direction of multimedia.

Less clear is the process in the aesthetics of industrial design. If we compare it with what has happened in art and music, we can see how these new methods have not only modified traditional languages, or even thrown them into crisis in an unchecked broadening of the field of aesthetic investigation, but have also changed the perceptive modalities and uses of art.

New trends and groups of artists have been operating for some time now under the headings of video art, web art, digital art, electronic music, and so on. Making explicit use of computers, they are experimenting with alternative languages and multimedia interconnections, often with extremely interesting results.

So the question is whether or not a new formal language equal to that developed in the other arts can be recognised in design as well – already supported for many years now by instru-

ments like CAD (Computer Aided Design), CAS (Computer Aided Styles), CAM (Computer Aided Manufacturing), CIM (Computer Integrated Manufacturing), and, for graphics DTP (Desk Top Publishing).

The answer is not simple for three reasons.

The first is that, although designers are being asked to accept the scientific and technological progress in their work, they do not always recognise, and often underestimate, the influence of tools and methods on their poetics. They are used to making predominantly individualistic, and more generally aesthetic/practical interpretations of linguistic transformations, even in the presence of basic technical and procedural innovations.

A good example of this problematic relationship is represented by the use of Renaissance perspectival vision, to which important thinkers such as Erwin Panofsky, Pierre Francastel and Decio Gioseffi have dedicated themselves. The simultaneous assertion of a new concept of space on the one hand and humanistic practice on the other – which not just a few architects and artists tended to underestimate, even while applying it – is a critical source of confusion, not yet completely resolved as a result of the different interpretations made of the phenomenon.

Vasari, in speaking of Paolo Uccello, one of the first to develop this method of representation, expresses a harsh judgement of the painter:

> Who, gifted by nature with a sophisticated and subtle talent, took no greater delight than in investigating things from difficult and impossible perspectives which, the more capricious and beautiful they were, the more they impeded him in those figures that later on, as he grew old, he continued to paint worse and worse.

In reality, beginning with some scientific principles, mathematics and geometry in particular, perspective was becoming a kind of new media; a means which, interpreting space as the site of new objective relations rather than as experience, was radically transforming the language of formal representation,

involving all forms of artistic expression, and architecture most of all.

The second reason is a psychological one and concerns many architects who began working before the diffusion of the computer. (Let us remember that we are only at the beginning of what could be called the digital age.) These architects did not have – and continue not to have, for practical reasons – an easy relationship with this medium. On the one hand, there is the preoccupation with having to deal with a *formidable* technology which requires a complex resetting of previously adopted design parameters in order to control it. On the other hand, there is the stress of faster and faster adaptation of these technologies compared to the unlimited and timeless use of traditional means such as pencils, rulers, set squares and compasses that pre-date the computer. These are aspects that regard, in equal measure, both the fields of architecture and industrial design. Both are disciplines which use the same basic methods and can be traced back to a common *design practice*, though in different applications.

The third reason, certainly the most significant because of its aesthetic implications, regards the nature of computerised methods and their ability to influence – and we will try to discover how – the creative process and the development of a formal language. The shifting of aesthetic research towards more and more metaphorical contexts, and the gradual estrangement from the manual and material nature of objects before they actually exist, might seem to be a sign of man's reduced control over creativity; a clear contradiction to many aesthetic theories based precisely on man's manual ability to make things. In other words, the loss of personality and individual expression are feared in the face of a technological *interference* which tends to continually broaden its range of capabilities and its territory.

Because of the clear socio-cultural analogies which, then as now, profoundly modified the entire society, we should remember here that very heated debate which arose in the 56 late 18th century and lasted throughout the entire 19th century, spawned by the industrial revolution. Argan speaks of this

period as witnessing "the progressive crisis of the finished object". Intellectuals, scientists and artists clashed on many themes. Among these was the very resounding one which, in contrasting the artisan to industry, focused on the nature of the new mechanical means that science was placing in the hands of architects, artists and artisans; means in which many failed to see an aesthetic dimension while, in reality, the language of art, and more generally, culture, was simply expanding its borders. The debate on the aesthetic quality of objects only came to an end in the early 20th century, with a certain delay compared to other artistic disciplines, when, thanks to the Modern Movement, a more solid and coherent relationship between the designer and the world of production was established, giving birth to industrial design.

1.2 Traditional Means and the New Design Approach

Without emphasising too sharply the generational aspect, it must nevertheless be said that the digital problem does not really exist for young people who have grown up using computers in school. They use the computer and its software – for them by now the most *natural* means with which to work – just as once upon a time the drafting machine, set square, orthographic projections, perspective and so on were used. If anything, we should reflect on the contemporary world's dependence on computer technologies. Paradoxically, if the computer were to suddenly cease to function, then new generations would suffer a very significant regression given that, in school and daily life, many age-old manual practices have been laid aside and in part forgotten. This is a phenomenon that has been repeated other times throughout history. Innovation, or at least the transformation of technologies, has always led to the abandonment of a practical heritage considered obsolete. Just consider the graphic representation of buildings and 57 objects in classical perspective, of the various orthographic and axonometric projections and of model-making. Practically all have been replaced by virtual two- or three-dimensional representations which, with their procedural automatism, render the knowledge of construction rules

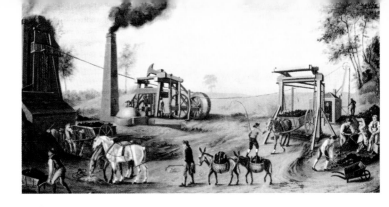

MEANS, OBJECTS, COMMUNICATION

The conflict between practice and technology began with the industrial revolution when, for the first time in history, the landscape, the city and objects began to radically change. The ensuing debate focused on the nature of the new mechanical methods that scientific research was making available to designers, artists and artisans; methods in which many failed to see an aesthetic dimension. In reality, the language of art and, more generally, of culture, was simply expanding its borders and profoundly transforming the shape of things and of communication.

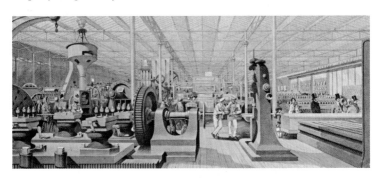

Above: the birth of the industrial landscape in an anonymous painting from around 1820: a steam-powered winch at the entrance of a mine. Centre: an image of the Machine Salon at the Great Exhibition of 1851 in London. Left: advertising billboards on a corner in New York in the early 1960s.

TOWARDS A NEW DESIGN APPROACH

With an importance equal to that of perspective in the 15th century, not merely a means of representation but also a new way of communicating, the use of the computer is profoundly changing design techniques, allowing the designer to gradually replace traditional graphics and models with new methods, virtual models and animation, and so express and shape thoughts at a speed never known before.

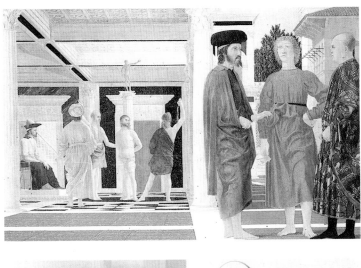

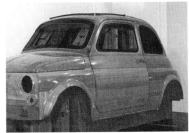

Above: The Flagellation *(1495 ca.) by Piero della Francesca, Urbino, Galleria Nazionale delle Marche. Centre: mahogany model of the Fiat 500 (1956) by Dante Giacosa. Below: design for* Pocket, *or* Traveller's, Bottle *(1999) by Giovanni D'Ambrosio, rendering.*

apparently unnecessary. This leaves the operator alone in controlling the aesthetic quality of the final result; an apparently simple operation but in reality full of important implications, as much from the point of view of composition as of the communicative power of the design. With the vast range of choices offering extremely rapid switches of graphic quality, point of view, illumination, colour and texture (difficult to obtain with traditional means), the results obtained are as expressive as the operator is creative and knowledgeable in his use of the means, and how able he is to generate meaningful images that avoid stereotypes and facile effects.

But obviously the designer's choice is not limited to the final result. He can intervene at any stage in the design process – and this is the most important and revolutionary contribution that the computer offers the designer – partially or entirely modifying the initial idea, consolidating, cutting, deforming, shifting, superimposing and verifying every step of the creative process until he obtains the most satisfying results. Furthermore, in eliminating a lot of execution time and material manipulation connected with the traditional processes utilised in transforming the design idea into reality (paper, pencils, ink, replacement of techniques and instruments, preliminary sketches, alternatives and modifications, final drawings, variations, perspectives, models on different scales), computers have enormously shortened the distance between the dawning of an idea and its taking shape. The designer is allowed to compose and mould a thought in progress at a speed never before known, generating a series of expressive short circuits which have a definite influence on the final result.

The fundamental difference should be noted here between a designer or architect and an artist in the moment when they utilise a computer to produce their work. The designer is clearly aware that what he is doing is *not* the piece itself (here his attitude is identical to that which he had using traditional techniques). His drawings, renderings and animations only *allude* to the work as a metaphor whose implicit linguistic clarity is the only way to assure its perfect construction, i.e. the drawings have an informative, and not aesthetic, function

since they must be understood completely by the people actually making the object or building. The artist, on the other hand, needs to immediately give his designs aesthetic meaning, whatever means he uses, since he is precisely creating his final work at that moment, even if it is reproducible, as in the case of an etching, a video or a web page.

From this point of view, there is no doubt that the designer is helped greatly by the use of computerised methods since, by utilising highly informative signs and instruments with a low aesthetic quality, he can detach himself from the signifier and focus his energies on meaning.

1.3 The Art of Manipulation

But can the computer generate aesthetically meaningful forms and languages on its own? Leaving more articulate answers to scholars of artificial intelligence, we can only note here that the capacity of a machine to *think* (remember, the computer carries out only what it is programmed to do), to act completely autonomously, continuously acquiring new information from multiple sources, allowing it to choose from stored input (and therefore *create*) is still a distant goal. The system cannot recognise shades of meaning and differences dictated by the context. For the computer Angela's *breast* and the *cove* of Lake Como (both italicised words translate as *seno* in Italian) are the same thing – for us obviously not. The creative act is the result of the unexpected, the interruption of an ordinary sequence and continuity. Creativity raises the level of entropy, the state of disorder, forcing us to continuously revise linguistic codes so that the new information produced can be transmuted into cognitive signs.

With its ability to think, the computer is rather the contrary of human creativity since something unexpected, the casual interruption of a sequence (it is understandable that programmers are not able to predict the infinite combinations that software might activate) can, in the majority of cases, be the equivalent of a system crash or, at the very least, a software malfunction. The essential feature of a computer system is, therefore, its complex *order* and hierarchy requiring stability

THE CULTURAL ROOTS OF THE DIGITAL IMAGE: THE AVANT-GARDE

With the historical avant-garde, traditional languages were disrupted and reorganised semantically with an imaginative energy reaching out in all directions, leaving an extraordinary cultural legacy for the following generations, who drew freely from the many ideas and formal solutions developed in those years, solutions which have turned out to be decisive even in today's digital age.

Above left: Merzbau *(1920s) by Kurt Schwitters. Above right: photographic collage (1920) by Hannah Hoch. Lower left:* Bicycle Wheel *(1913-65), readymade by Marcel Duchamp. Lower right:* Villica Caja *(1930) by Francis Picabia.*

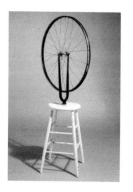

THE CULTURAL ROOTS OF THE DIGITAL IMAGE: POP ART

Members of the generation that invented the computer, software and the Internet were almost all born in the 1940s and 50s. The cultural models that contributed some of the fundamental ideas found in many digital processes were those from the 1960s and 70s: student riots, the rediscovery of the historical avant-garde movements, Pop Art, Structuralism, Feminism, Rock & Roll, radical politics…

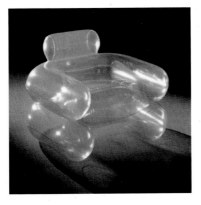

Above left: As I Opened Fire… *(1964) by Roy Lichtenstein. Above right:* Ghost Typewriter *(1963) by Claes Oldenburg. Below: PVC armchair* Blow *(1967) by Scolari, D'Urbino. Lomazzi and De Paz, produced by Zanotta.*

and certainty of communication. Without this, the flow of information, and especially the speed of data transmission, would be lacking. As a matter of fact, in the 1940s and 1950s, use of computers was restricted to scientific and administrative contexts (calculating and cataloguing data). Applications in the field of design and, more in general, in art had not yet been sufficiently developed.

When experimentation with computers in the field of graphic design began seriously in the 1960s with the passage from the alphanumeric form to that of graphic icons, where bits – whose quantity varied according to the resolution desired – were composed of picture elements known as pixels, a basic contradiction in the new means came to the foreground. No sort of creativity was possible given that the automatic combinations and the resulting semantic capacity were banal and repetitive. This was because the computer, in order to produce information, had to operate in a situation of low entropy, hence with minimal disorder and a predictable capacity to sequence.

During that same period, a kind of programmed art form began to spread that drew its expressiveness from computer-generated graphics. A number of its Italian exponents worked as industrial designers. Two of the most important were Bruno Munari and Enzo Mari. Despite the praise of critics like Giulio Carlo Argan, the experience was short-lived, both as a result of the ascetic formalism of the works of the most intransigent artists, and of the reduction to pure optical games by those who, instead, were looking for a more facile public acceptance.

Added to this theoretical contradiction was the related operational capacity in terms of internal architecture, RAM (Random Access Memory) and ROM (Read Only Memory) that the computers offered at the time. The programs dedicated to design in general were built ad hoc and often did not interact with analogous or pictorial applications, both because of the difference in their native formats as well as the quality of the operating systems. Around 1965, only about 1700 of them were in circulation! In addition, the procedures were very complex and costly, two reasons why computer use

was restricted to the military, universities and large industrial conglomerates.

The use of the micro-chip, the process of miniaturisation, the gradual increase in the machines' potential power, the continually improving interface and the increase in application software, which has become more important than hardware over time, are all elements that have substantially encouraged the diffusion of the personal computer. In simplifying their relationship with humans, computers have become a more and more flexible tool, used not only for professional tasks but in other aspects of daily life as well.

In the early 1980s, the computer made its way into the professional studios of architects and designers, timidly at first, its use limited almost exclusively to the execution of drawings. Later its possibilities were broadened as it assumed a more and more central role, graduating from mere instrument to indispensable support in every phase of design and beyond, since the simulations obtained with rendering and animation became extraordinary vehicles of communication with both the client and the public at large. But how was that contradiction resolved?

Perhaps when it was recognised that the designer could use the computer on two distinct but closely related levels. The first concerns the capacity of the computer system to operate on linguistic codes that can be deconstructed, analysed and brought down to their most infinitesimal unit – the bit, defined by Nicholas Negroponte as "the smallest atomic element in the DNA of information". The second permits operations on formally defined single *objects* or groups of objects, components, from the simplest to the most complex, that can be utilised either in their formal and perceptual whole or by modifying their dimensional parameters (arriving even at a profound transformation of their aesthetic meaning), with the aim of integrating them into whatever design context is desired.

This extraordinary propensity of the computer to produce linguistic combinations of low aesthetic intensity but with a high informational implication for the operator led to an absolutely revolutionary expansion of the designer's creative potential, which can be summarised in one word: manipulation (whose

FROM STYLE TO DESIGN: THE SEARCH FOR ALTERNATIVE LANGUAGES

The current phase of industrial design, and architecture, is characterised by the abandonment of the idea of style in favour of a more liberal exploration of design. This trend, while aided by digital capabilities, has also had numerous precedents in history such as in the early decades of the 20th century. More recently, this trend has been seen in the use of signs and archetypes from the mechanical and scientific-technological world, that had always been considered unaesthetic.

Above left: The Bride Stripped Bare by Her Bachelors, Even (Large Glass) *(1915-1923) by Marcel Duchamp. Above right:* Allunaggio *stool (1965) by Achille and Piergiacomo Castiglioni, produced in 1980 by Zanotta. Below: the Pompidou Centre in Paris (1976) by Renzo Piano and Richard Rogers.*

FROM STYLE TO DESIGN: THE CONSUMPTION OF HISTORY

The spread of the computer during the 70s and 80s coincided with the arrival at a sort of "level zero" for design methods, determined by the linguistic absorption of many preceding styles (including historical ones such as Neo-classicism) polemically brought back to fight the exhausted final stage of Rationalism. These movements, groups and isolated personalities, though operating with different ends and results, were frequently indicated as expressions of post-modern culture.

Above: the Carlton *bookshelf (1981) by Ettore Sottsass, Jr., production Memphis. Centre:* Marilyn *sofa (1981) by Hans Hollein, production Poltronova. Below: model of the church* Dives in Misericordia, *project by Richard Meier in the process of being built at Tor Tre Teste in Rome.*

break-through efficiency is posing very serious ethical problems in bio-technologies and nutrition with cloning and the spread of genetically engineered foods). From this point of view, the intervention of the operator would become more decisive and aesthetically meaningful the more he used the computer for subversive and *disordering* purposes. However, we do not refer to disorder as chaos, the total absence of order, but as a *different* order with elements that originate from sets whose relationship has yet to be constructed. In other words, the designer has a new and different opportunity to manage creative complexity, moving from traditional design processes – where modifications develop over time as the result of a series of individual manual operations such as erasures, new additions, changes in technique and the building of models – to a new combination process where the various techniques are all generated by the same means and all alternatives co-exist and can be easily combined in extremely reduced time-frames. This process is analogous to what has taken place in film-making – where many scenes in spectacular films are being increasingly created on computers – or music where, with a sequencer (a real musical dissection table), a digital score can be manipulated, modifying its melody, rhythm and key, highlighting the various instruments or even replacing them with others, isolating individual notes and so on, with total control over the composition and its genetic structure.

1.4 The Cultural Roots of the Digital Imagination
It is well known that the first graphic interfaces represented a working environment that recreated the experience of sitting behind a desk. Later, as a result of the increase in materials that had to be located on the monitor, the interface evolved into one decidedly more abstract, the window. Only the folder and wastebasket remained to recall the old office habitat, an obvious and appropriate metaphor given that it communicated a common message to all. But this wasn't the only possible interface, and it is not necessarily true that the window itself may not change at some point. A keyboard is used to communicate with the computer, but it is already possible to do so

simply by touching the screen or using voice commands. Even the most radical innovations spring from the unknown, generate other innovations, and so on until the oldest model is set aside. Even the computer has practical roots that have caused its creators to configure it in a certain way and this is one possible piece of evidence.

Manipulation is one of the linguistic/design practices belonging to the artistic avant-garde – Dada, Surrealism, De Stijl and so on. These groups, with obviously different aims and results, combined different exercises not unlike those of alchemy and other esoteric practices. The close relationship between many avant-garde artists and the world of esoteric wisdom is well documented. One of Duchamp's major works, his *The Bride Stripped Bare by Her Bachelors, Even (Large Glass)*, is only understandable in terms of alchemist's symbols, while the poetics of De Stijl drew inspiration from spiritualism and Theosophy. But beyond these connections, mentioned only because the esoteric has always been a source of symbols and *alternative* language resulting from the intermingling and overturning of meanings, what is important to us here is the particular interest of the avant-garde in the manipulation of traditional languages. They always utilised them ambiguously and with a methodology which disrupted its codes and then semantically re-ordered them, often in arbitrary ways. Tristan Tzara, founder of Dada, in the *Manifesto on Free Love and Bitter Love* published in 1920, formulated the recipe for a Dadaist poetics:

> Take a newspaper. Take a pair of scissors. Choose an article from the newspaper that is the length you would like your poem to be. Cut the article out, and then carefully cut out every word that makes up the article and put all the words into a bag. Shake slightly. Take the words out of the bag one after the other and arrange them in the order in which they come out. Copy them faithfully. This will be your poem. So there, you have become "an infinitely original writer with a charming sensitivity"…

Aside from the sarcasm – a fundamental element in many avant-garde statements – what comes out here is the system-

Plasticity & geometry: technological neo-classicism

Formal elements like symmetry, plastic compactness and impassive executional finiteness, combined with metaphysical composure, place these (super) objects – which express a possible harmony between aesthetics and technology – on the one hand, in the context of the Rationalist tradition and, on the other, in the flow of a refined technological Neo-classicism resulting from its unmistakable aspiration to the sublime.

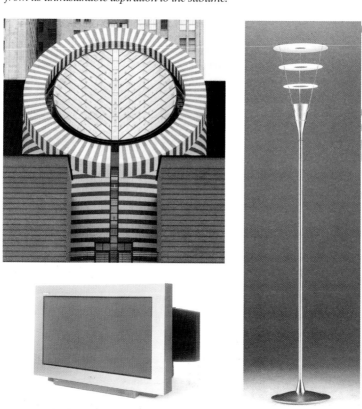

Above left: San Francisco Museum of Modern Art, San Francisco (1990-95), by Mario Botta. Right: Saturnina D25 *(1999), floor lamp with dimmer and coloured filters, by Afra and Tobia Scarpa, production Fabbian. Lower left: 32-inch* FD-Flat Display *with a flat, non-reflective screen, designed and produced by Sony.*

PLASTICITY & GEOMETRY: LIGHT AND MODELLING

The total stereometric control of modelling, surfaces, textures and, fundamentally, light, that enhances plasticity or pure geometry, are features that unequivocally distinguish the forms of these objects, born out of digital technology, from those preceding them, even though they might have analogous formal characteristics.

Above left: Hi-Pad *chair (1998), covered in felt with steel legs, designed by Jasper Morrison, produced by Cappellini. Above left: leather suit designed and produced by Trussardi. Below: the Fiat* Bravo *(1995), designed by Centro Stile Fiat.*

atic process and order of the method suggested by Tzara, against results which finds its explosive creativity precisely in this disorder where everything is possible and nothing predictable. Among the many Dadaist inventions, the photomontage merits special mention. One of the techniques most used in digital graphics and illustration now, this is something completely different from the Cubist collage, where the insert had essentially a decorative value. In the photomontage, each part of the whole is a thing in itself with its own meaning. But when combined with other equally meaningful elements it takes on a new significance. Raul Hausmann, who developed this technique around 1917, observed in his article *Definition of Photomontage*:

> The Dadaists that had 'invented' static simultaneous and purely phonetic poetry consequently applied the same principles to figurative representation. They were the first to use photographic material to add new unity to structural elements which were often contradictory in nature, both in the material and spatial sense.

How can we fail to mention the magical and hallucinatory piazzas of Giorgio De Chirico, the paintings and collages of Max Ernst, the *Ready-Mades* of Marcel Duchamp (true examples of semantically *alternative* design where the object assumes an unforeseen function in contrast to its original one, comparable to the upside-down rituals of the black mass), the Pompier paintings of René Magritte, or the precocious deconstruction of Kurt Schwitters?

These extraordinarily creative cultural models which, let us not forget, contributed to forming some of the fundamental ideas found in many computer procedures, were filtered and acquired through the ferment of the 1960s and 1970s, a period when historic avant-garde movements were recalled and reactivated (for example, Futurism was re-evaluated in Italy after a long silence). The generation that made possible the capillary diffusion of computers both in the workplace and the home, the Internet included, is made up of people almost all born in the 1940s and 1950s, and educated to the accompani-

ment of student riots, Pop Art, Structuralism, Feminism, rock & roll, radical politics, the rejection of imperialism and the Vietnam War. Not surprising then that more than one scholar sees the birth of the personal computer as the result of the struggle of young radical American (and non-American) researchers. Among these were the People's Computer Company which fought to wrest computers from the exclusive hands of military and scientific environments and large corporations, and make them accessible to everyone.

Those were years when everything was being seen in terms of *communication* (today, the key word is *information*) and the world was beginning to resemble, according to the much-quoted term of Marshall McLuhan, a "global village". After the manual approach of abstraction in the extreme manifestations of Action Painting in the 1950s, art began to shift its attention to the city as a place where two fundamental rites of the capitalist society were manifest: communication and consumerism. Architecture and industrial design, abandoning the ascetic functionalism of the 20th century masters, began to develop a new iconographic system made up of hyperbolic forms and semantic interference. In 1972, Robert Venturi, in collaboration with his wife Denise Scott Brown 56 and Steven Izenour, wrote *Learning from Las Vegas*, which re-evaluated the city as an unequalled source of signs and communication. Then in 1977, McLuhan published a book, intended for schools, with the significant title *City As Classroom: Understanding Language and Media*.

In taking up many of the linguistic exercises invented by the Dadaists, Pop Art (at times called the New Dada) brought the materialistic and persuasive iconicity of mass society to a more and more metalinguistic and virtual dimension. It transferred to the field of art the imaginative mythology of popular culture and the kitsch of daily life. Cartoons, cinema, television, advertising and consumer objects were the new *signs* from which artists and designers drew their inspiration. These objects (furniture, clothes, graphics) had exceptional semantic redundancy, all seeming to declare a common desire for communication and diversity through a frenetic exchange of lin-

PLASTICITY & GEOMETRY: MINIMALISM AND ERGONOMICS

The relationship to objects, especially technological ones, was once one of conflicting for most people. It seems less so today as a result of the ease of approaching these objects and the adoption of a simpler and more ergonomic design (more often than not minimalist) that enhances the tactile quality of surfaces in the places where the objects must be touched or manipulated.

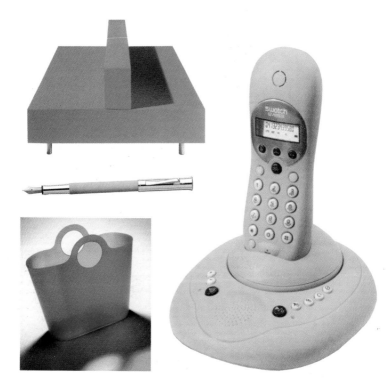

Above left: Blue Bench *(1998), polyurethane-painted sofa by Marten van Severen, production Edra. Lower left: pen with plume motif engraved on its shaft, design and production Faber-Castell. Right:* Swatch Cordless II Answer *(1998) telephone, design Toxic Rosella, production Swatch. Below left:* Rond *(1966) polypropylene bag, design Hansjerg Maier-Aichen, production Authentics.*

Many of the objects and spaces that make up our habitat reveal a notable perceptual instability, with a dynamic and precarious equilibrium, conceived overall as groupings of non-homogeneous parts whose sum is often the result of a montage in which the forms are highlighted not only by the joints but also by contrasting materials and colours that isolate their contours for an overlapping or collage effect. In this way many of the objects' functions are isolated and emphasised.

Above left: model of the design for the Faculty of Architecture of the University of Cincinnati, Ohio (1988-91), project by Peter Eisenman. Right: The Brain *(1999), watch designed by Brian Delaney, produced by Fossil. Lower left: shoe (1999), design and production Manufacture D'Essai. Lower right:* City Coupé *(1998), designed and produced by Smart.*

guistic codes (high or low it didn't matter), passing from one generation to another with a fluidity never seen before.

The series and reproducibility were no longer considered negative values and became part of artistic licence, upsetting the idea of the unique work of art. (For example, the use of the photograph in the *serial* works of Andy Warhol, and the diffusion of plastic, which, with its synthetic and reproducible nature, was also inexpensive, represented for many designers a vehicle for Democracy as well as Modernity).

Moreover – art has always been first to explore certain territories – the artistic product began to come into question, to the point of practically disappearing, with the assertion of ever-less material art forms that would come to be known as Conceptual Art, Behavioural Art and Video Art. This was a period when an expression began to circulate that several years later – today, that is – would become the supporting element of an entire cultural system: Virtual.

1.5 From Style to Design

The implicit capacity of the computer to intervene in the creative process, enormously amplifying the information upon which a majority of formal choices depend, has gradually distanced designers and architects from the idea and practice of style which Henri Focillon defines in his essay *The Life of Forms*: "The formal elements, which have an index value, which are its repertoire, vocabulary and, sometimes, its powerful instrument. Still more, but less obviously, a series of relationships, a syntax." Actually, the concept of style used by the historians of various artistic disciplines to identify and catalogue the works of individual artists and various other cultural expressions that have taken place in time and space, useful also from the point of view of written history, has often proved contradictory and not always appropriate to justify sudden changes, the co-existence of diverse forms or even the absence of style (if not that of a personal study) in any single artist. Let us consider, for example, the stylistic virtuosity of a Robert Adam who, in the 18th century was designing Neo-classical, Gothic and Rococo furniture or, more recently, of the experi-

mental production of Marcel Duchamp and finally, of the [64] design process of the Castiglioni brothers marked by their constant and coherent rejection of style in favour of the search for a design not infrequently related to the work of Duchamp.

Without evoking other historic episodes where the concept of [65] style has been disputed, we should also point out, more recently, the fatal blow delivered by the Memphis Group led by Ettore Sottsass, with its extravagant and anti-functionalist avant-garde objects and furniture that were very successful in the 1980s. Then there was the Post-Modern movement, whose hyper-mannerism (but then what is mannerism if not a rejection of style, the individualistic approach of those who refuse to belong and claim the freedom to create?) erased the continuity with the Modern Movement still obstinately sustained by many design and architectural historians, but which many designers no longer recognised, preferring to polemically turn back towards pre-Rationalism.

The Memphis group having dissolved and Post-modernism exhausted as a result of a kind of linguistic bankruptcy, there remained the need to open up new horizons, to use design as a way of finding the solution to a problem, as Enzo Paci wrote, so that "operation takes place in a field from which the infinity of paths is excluded along with the concept of one single path; the historical process is not exhaustible if not at the limit of the form of operating," and further, "Every form is a tension between the element of permanence and the element of emergence." It is in this very delicate phase, this continuing necessity for choice that interrupts and establishes relations to let new forms emerge, that the computer has demonstrated its effective possibilities. Here it allows a return to the experimentation and manipulation at the basis of a design that does not want to use codified stylistic elements and preordained solutions.

The current passage from style to project, common to all aspects of design, fashion included, is seen, therefore, as a phenomenological study of form, which, obviously, does not mean formalism or absence of meaning but greater individual control in every phase of the design process. Meaning, of course,

ASSEMBLAGE, JOINTS & CONNECTIONS: EVERYTHING MOVES

The intention of the designer in this type of object is often not a complete form but the sense of its becoming form, underlining the implied dynamic in each shape and visualising its possible transformation from one state to the next, with clear high-tech echoes.

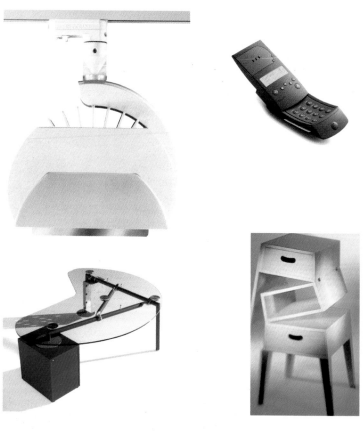

Above left: projector from the Linea Meridiana *series (1998), design Fabio Reggiani, production Reggiani. Above right: prototype for cell-phone* SL10 *(1994), design Hatto Grosse, production Siemens. Lower left:* Isotta *desk (1998), design Lorenzo Marcolin, production Ultrom. Lower right:* Table-Cabinet *(1995), prototype, design Shin and Tomoko Azumi (photo J. Hawkins).*

Having rejected the principle of compactness, and also often symmetry, we witness the dispersion of the various structural elements, freed within their context, making each individual part outstanding and significant.

Centre: Twiny, *liquid gas cylinder (1998), design and production Liquigas. Lower left:* Joker *(1998), closed hearth fireplace, design Andrea Crosetta, production Antrax. Lower right:* Cobàn *(1997-8), coffee maker, design Richard Sapper , production Alessi.*

concerns language, and the more experimental and innovative it is, the denser the content will be. Abandoning the directives (or dictates) of style – which exists only if connected to the concept of duration, today considered decidedly unimportant given the continual shortening of the interval between the emergence of an aesthetic form and its disappearance – liberates creative fantasy in order to more fully express the multiplicity, contradictions and velocity of the world around us.

2. The Form of the Project

2.1 The Formal Categories

If we accept the idea of abandoning style in favour of a more aware and articulated design practice – in a period such as this, when rapid exchange, fragmentation, the co-existence of diverse or even contrasting forms are dominant, and when it is clear that style needs stability and continuity in order to take shape, develop and, above all, be acknowledged – the problem arises of how to identify the strong elements that can guide us through the tangle of these individual expressions that, drawing on analogous processes, produce forms that can be grouped into relatively homogeneous categories; all this, with the aim of composing a clear and rational map of contemporary design practice.

Significant attempts have already been made in the past to identify critical tools as alternatives to those which were based on style. For instance, the studies of Heinrich Wölfflin, who developed a system based on contrasting pairs: linear/pictorial, flat/perspectival, light/dark, closed/open and simple/complex. Beginning from Wölfflin's theories, criticised by some for being excessively schematic, Paul Frankl conceived a more complex system at whose centre he placed two contrasting categories: the Being and the Becoming of forms. The analyses of Alois Riegel are also highly noteworthy. Focusing his studies on transitional periods – the most confused from the point of view of style and hence less easy to catalogue – he identified, in turn, two other main contrasting categories, tac-

tile and pictorial, as well as making an important contribution to the figure/background relationship. In more recent times, we owe a further study to Bruno Zevi, which led him to the definition of seven constants in modern design to be juxtaposed with classical ones: asymmetry, three-dimensionality, technological structure, spatiality, horizontal and vertical reintegration, and non-finiteness. These studies confirm the awkwardness of art historians and aestheticians in analysing the problem of form and its transformations, which categorisation in periods and styles is not always able to fully explain.

Since this study is focused on the epochal renewal brought about by the use of computer technology, the indications by which to identify a series of formal categories will be drawn precisely from the operating practices offered by the computer. Though also traceable with different features to previous periods, these categories have today assumed some well-defined and recognisable characteristics. This series of formal categories also gives an explanation in terms of design approach, the co-presence of diverse languages – also, and even better, if they are contrasting – in individual designers or homogeneous professional groups, not counting the fact that many objects display elements of one or another category which, mixed together, co-exist by integrating each other.

– *Plasticity & geometry.* These are formal elements that, even if always utilised in industrial design, assume an almost metaphysical perfection with the use of the computer that lifts these objects out of the context of time and, therefore, out of history. The total control over stereometry, modelling, surfaces, textures and the fundamental component of light, which enhances their geometric and plastic aspects, are the procedures that make it possible and easy to distinguish new forms from previous ones.

– *Assembly, joints and connections.* The free assembly of forms and the perfect connection between parts are obtained, thanks to the treatment of the various elements as objects, manipulated either individually or in groups. This category fully expresses the experimental and combinational design capacity of the computer: diverse forms dynamically seeking

TRANSPARENCY: COMPLEXITY & SUPERIMPOSITION

While it does express the lightness and depth of space, transparency is the opposite of simplicity. Its use implies complexity, uncertainty and multiplicity. It can render bodies immaterial and at times be a protective screen, a membrane that allows a glimpse of forms and functions without the need to enter into contact with them.

Above left: pyramid at the Louvre in Paris (1989) by I.M. Pei Right: two transparent dresses from the "Versace Atelier" collection (1998), designed and produced by Versace. Below: iMac G3 computer (1999), design Jonathan Ive (co-ordinator), Danny Coster, Chris Stringer, Daniele Deluiis, production Apple.

TRANSPARENCY: SPACE, TIME & RELATIONS

The visual superimposition inherent in transparency multiplies the elements of an image making it often more difficult to identify. Moreover, in three-dimensional objects transparency does not have a static function, but changes with every movement of the observer. Space, time and the relationships between the parts are the fundamental elements in reading transparency.

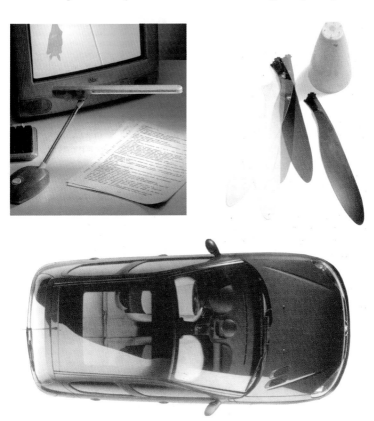

Above left: e.light *computer lamp (1999), design Ernesto Gismondi, production Artemide. Right:* Blow *fan (1996) in methacrylate with coloured, transparent blades, design Ferdi Giardini, production Luceplan. Below:* 206 Roland Garros *car with glass roof, design Peugeot Style Center, production Peugeot.*

a common order and parts which connect to each other by means of a reciprocal formal relationship.

– *Transparency.* This is one of the preparatory steps that saves the images from being overloaded in the design phase. Although a graphic expedient allowing us to view the object under construction as transparent with a fine wire frame, it has the capacity to generate very evocative images which have greatly influenced both industrial design and architecture, transforming vision into the cognitive exploration of space, with forms superimposed and mixed together that express the complex plot of experience through constantly changing relations.

– *Deformation.* The processes related to the computer's manipulative capacity: lengthen, squeeze, rotate, multiply; the modification of all the features of a regular shape allowing the designer to explore expressive territories visited previously only by the plastic arts, abandoning that typological rigidity common to both industrial design and architecture which has characterised much of the design of past years.

68-69, **2.2 Plasticity and Geometry**
72 In both cases, curvilinear or rectilinear, volumetric forms are tense and compact, often symmetrical, tangible testimony to the dominion of Man over matter. Either that or they conceal an internal structure or just hint at it, communicating a degree of metaphysical completeness in the object that borders on the absolute, in a sort of evocative demonstration of perfection and potency that places the majority of these (super) objects in the stream of the rationalist tradition. But even more than rationalism, to which these forms inevitably refer, here we are faced with a sort of technological Neo-classicism, a search for perfection and the sublime that recalls the art of Jacques Louis David and Antonio Canova.

In particular, the objects recognised in this formal category can be placed alongside the work of neo-classical sculptors, who sought an almost abstract perfection through the creation of a clay model of the piece first, then its the plaster cast used later by assistants to make one or more marble replicas under the critical eye of the master. This caused an aesthetic

"cooling off" of the plasticity and a total depersonalisation of the piece (serialisation, in multiplying the original, somehow annuls it) relegating it to an a-historical dimension. Moreover, it must not be forgotten that the study of light effects on the surface of marble, just like a rendering in which the intensity and direction of the light can be controlled, allowed neo-classical artists total control over their forms.

Among the numerous examples we could give to illustrate the above, the formal mutation carried out in automobile design is particularly relevant. This has completely lost that *box-like* effect, very common up until a few years ago, in order to take on a terse and sculptural plasticity that tends to eliminate the diversity of the parts, underlining a total and uniform design enhanced also by a broad use of metallic paint finishes that give aluminium an honesty equal to that of the Carrara marble of Neo-classical statues. More generally, many technological objects, like cell-phones, television sets, hi-fi stereos, computers and lamps, are inspired by these same formal ideas. This same concept is also seen in furniture, fashion and the simplest of objects, and also in the essential approach of the architecture of Aldo Rossi and Mario Botta.

2.3 Assembly, Joints and Connections

73,
76-77

This formal category, whose features are in contrast to those of the preceding one, refers to a series of phenomena by now well-ingrained in contemporary visual culture: asymmetry, dynamism, fragmentation and the intermingling of shapes, colours and materials. In particular, many of the objects and spaces that make up our habitat reveal a notable instability of perception, with a dynamic and precarious equilibrium, conceived as overall groupings of non-homogeneous parts whose sum is often the result of a montage in which the forms are highlighted not only by the joints but also by contrasting materials and colours that isolate them in their contours for an overlapping or collage effect.

With the principle of compactness and symmetry now rejected, we are witness to the dispersal of various structural elements (with clear hi-tech reverberations) placed freely within

84

Transparency can be manifested in various degrees, from total visibility all the way to opaque, softening and blurring colours, forms and signs that can appear or disappear. Transparency can dematerialise the solid side of objects, endowing them with unexpected features.

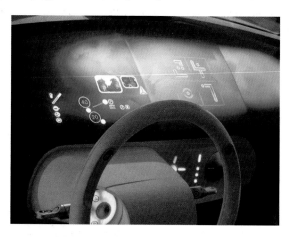

Above: dashboard of the Ford 24-7 *(1999), prototype, design and production Ford. Right:* La Marie *chair (1999) in transparent polycarbonate, design Philippe Starck, production Kartell. Below:* 6440 K-M Built-in *cooking surface (1998), design and production AEG.*

85

DEFORMATION: MATERIAL EXPRESSING ITSELF

Among the various possibilities of manipulation that the computer has made simple, the stretching and twisting of two- or three-dimensional forms is definitely among the most sensational. Symmetrical and regular objects can be deformed in a way that distorts their original image and changes their meaning, loading them as needed with new expressive elements whose wide range can run from an elegant neo-Art Nouveau to ironic caricature or expressionistic drama.

Above: building for the Dutch national offices in Prague by Frank O. Gehry (1992–97). Right: Oz refrigerator-freezer (1997), design Roberto Pezzetta and Zanussi Industrial Design Center, production Rex. Below: thermostatic mixer for Millennium *shower (1999), design Tinz.DCC, production Alpi.*

the context, making each individual part emergent and significant. The intention then is not to offer a finished form but its process of becoming form, underlining the dynamic implicit in each morphological constitution and visualising its possible transformation from a previous state to the next one. It seems natural to imagine a certain influence by the Memphis Group (and earlier still by Dada) on these objects. This is also true, but a fundamental difference is in their functional disposition – absolutely secondary in Memphis, where the object's aesthetic redundancy was the central issue – almost always fundamental in the category we are examining.

Indeed, many of the object's functions are isolated and emphasised: the car door, the buttons on the cell-phone, a door handle, table legs, the functional parts of a shoe, a bottle cap and so on, are not integrated but enhanced with the aim of establishing a relationship of interactive stimulation with the user, mitigating – in fact cancelling – that state of psychological subjection that Man has always suffered in the face of technology and, more generally, the workings of complex objects.

80-81, 84 2.4 Transparency

Transparency is a metaphor for the immaterial, expressing the lightness and depth of space. It is also the opposite of simplification. Its use implies complexity, indeterminacy and multiplicity. Sometimes it can be a protective screen, a filter through which forms and functions can be seen without the necessity of entering into contact or mixing in with them. There are many degrees of transparency from total visibility all the way to opacity, rendering the forms and colours soft and indistinct.

The visual superimposition inherent in transparency multiplies the elements of an image, often more complex making its identification. Moreover, the transparency of three-dimensional objects works kinetically, changing with every movement of the observer. In other words, transparency needs three fundamental elements to be grasped: space, time and the relationships between the parts. Very often in transparency the relationship between things is an oppositional one. For

instance, the inside and outside face each other, thus juxtaposing an ordered system – a protective shell or grid that identifies a recognisable spatial rhythm – on a disordered one – a tangle of wires, overlapping forms, grafts, contrasting colours, connections which, in attempting a definition, we could identify as "informal hi-tech".

Even though, as we have said before, transparency is one of the most typical functions of the digital operation, there are numerous historical examples of works and objects in which transparency is an important strategy; in the field of art, consider Duchamp's *Large glass* or Picabia's *transparent* paintings from the 1920s and 30s, in cinema the scene of the ballerina shot from below dancing over glass in René Clair's *Entr'acte* of 1924; in the context of industrial design, recall the 1940 "radio unit" by Franco Albini, the *Doney 14* television of 1962 by Marco Zanuso for Brionvega with its completely transparent rear casing, the transparent women's bags of the 1950s or the *Blow* armchair in PVC by the Scolari, D'Urbino, Lomazzi, De Pas group produced in 1967 by Zanotta.

Transparency has come back into fashion more recently with the appearance in 1998 of the Apple iMAC. A doubly important event: both for the recovery of the idea of transparency and the lucky intuition which, from that moment on, modified the form and image of the computer and, more generally, all technological objects, making them more fantastic and aesthetically interesting. Almost all objects have now given way to transparency: chairs, lamps, automobiles, cooking surfaces, clothes – adapting to an idea of visual complexity, which, in architecture, was expressed once upon a time in important works like those of Richard Meier and I.M. Pei.

2.5 Deformation

85,
88-89

Among the various possibilities for manipulation facilitated by the computer, the stretching and twisting of two- and three-dimensional forms is certainly the most spectacular. In fact, beginning with symmetrical and regular objects, we can obtain deformations that disrupt the original image and modify its meaning, loading it as needed with new expressive ele-

DEFORMATION: THE POWER FANTASY

*Many of these objects have elements that recall animal and vegetable forms,
or even the aerodynamic shapes of Futurism. But they also seem amusing
descendants of the imaginary and rather frantic world of cartoons.*

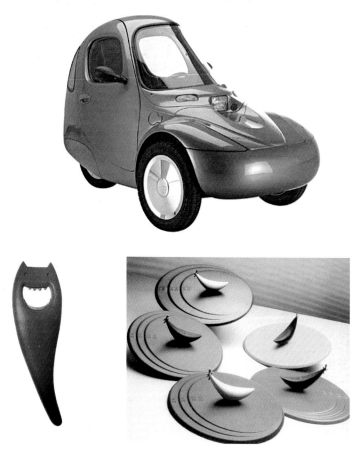

Above: Sparrow P.T.M. *(1999) electric single-passenger vehicle, design Mike
Corbin, production Sparrow. Lower left:* Diabolix *bottle-opener, design Biagio
Cisotti, production Alessi. Lower right:* Hop-1 *omelette flipper (1993), design
Roberto Nicoletto, production Ilsa.*

DEFORMATION: IMAGE FIRST OF ALL

Deformation emphasises the shape of the objects to such an extent that frequently their image, as in the designs of the 1960s and 70s, takes precedence over their utility. Their lines appear wavy and elongated, the shapes bulging, and the passage between one section and another is often sudden.

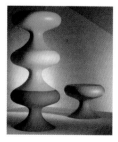

Left: wrist watch (1999), design Calvin Klein, production CK Watch. Right: dress from the Ferré Collection (1998), design and production by Gianfranco Ferré. Below: Jo-Jodi stackable occasional tables in polyurethane, design Massimo Iosa Ghini, production BRF.

ments whose wide range can be extended from ironic carica-
ture to expressionistic dramatisation.

The shape of objects is stressed to the extent that often com-
munication, as happened in the Pop design of the 60s and 70s,
takes precedence over function. Lines are undulating or
lengthened, plasticity appears inflated, and the passage
between the various sections is often sudden or almost with-
out mediation. Elements that recall in part natural forms, both
animal and vegetable, and in part the aerodynamic forms of
Futurism. They also frequently seem to come from the imagi-
nary and somewhat feverish world of cartoons with their
explicit and paradoxical humour. For many objects it is diffi-
cult to draw a line between one or another expressive formu-
la, given that sometimes a desired blending of types is evident.

For this formal category, as for the previous ones, there do
not seem to have been any exclusions from among the vari-
ous typologies in which industrial design is expressed. These
include automobiles that, with the diffusion of the City Car
and its chassis forced into rather unusual dimensions, have
assumed an amusing and unaggressive appearance and many
common objects that either suggest figures linked to the col-
lective imagination or else are presented more or less simply
in forms loaded with eroticism, if not explicit sexuality.
Scooters and motorcycles seems to be a separate phenome-
non where an apparently aggressive and aerodynamic, typi-
cally oriental, outline seems to have taken the upper hand,
but one which essentially appears a caricature given that their
possible maximum speed is decidedly inferior to the one
promised by their bodies.

Not all types of furniture lend themselves to deformation. In
fact, seating – chairs, armchairs and sofas – and small comple-
mentary pieces usually tolerate such manipulation better,
with occasionally curious and interesting results. Deformation
is obviously less used in the field of fashion but, nevertheless,
there is no lack of stylists experimenting with this, encour-
aged by the great international successes – or scandals – that
ingenious architects like Frank O. Gehry have created with
works that can be included in this formal category.

Bibliography

Computers, Design & Architecture

LIBRI

Aa.Vv., *The Solid Side*, Domus Academy - Philips Corporate Design, London 1995.

Ambasz, E., *Italy: The New Domestic Landscape*, MoMA, New York 1972.

Argan, G.C., *Progetto e destino*, Il Saggiatore, Milano 1965.

Boyer, M.C., *Cyber City. Visual Perception in the Age of Electronic Communication*, Princeton Architecturial Press, New York 1996.

Burdea, G., Coiffet P., *Virtual Reality Technology*, Wiley, New York 1994.

Dorfles, G., *Introduzione al disegno industriale*, Einaudi, Torino 1972.

Maldonado, T., *Disegno industriale: un riesame*, Feltrinelli, Milano 1976.

Bürdek, B.E., *Design: Geschichte, Theorie und Praxis der Produktgestaltung*, Du Mont, Cologne 1991.

Negroponte, N., *Being Digital*, Knopf, New York 1995.

Mitchell, W.J., *City of Bits*, MIT Press, Boston 1996.

Prestinenza Puglisi, L., *Hyper Architecture. Spaces in the Electronic Age*, Birkhäuser, Basel 1999.

Sanders, K., *The Digital Architect. A Common Sense Guide to Using Computing Technology in Design Practice*, Wiley, New York 1996.

Schmitt, G., *Information Architecture. Basis and Future of CAAD*, Birkhäuser, Basel 1999.

Smith, C.R., *Supermanierism. New Attitudes in Post-Modern Architecture*, Dutton, New York 1977.

Venturi, R., *Iconography and Electronics upon a Generic Architecture. A View from the Drafting Room*, MIT Press, Cambridge, Mass. 1996.

PERIODICI

Telèma, n. 15, 1998, *Il futuro della città nel mondo telematico*.

Telèma, n. 16, 1999, *Finzione e realtà del mondo virtuale*.

Domus. Architettura, design, arte, comunicazione.

Modo. Rivista internazionale di cultura del progetto.

Stileindustria.

Wired.

Aesthetics, Art, Style

Arnheim, R., *Entropy and Art. Essay on Disorder and Order*, University of California Press, Berkeley 1971.

Calvesi, M., *Duchamp invisibile. La costruzione del simbolo*, Officina, Roma 1975.

Calvesi, M., Boatto, A., *Pop Art*, Giunti, Firenze 1989.

Costa, M., *Il sublime tecnologico. Piccolo trattato di estetica della tecnologia*, Castelvecchi, Roma 1998.

De Micheli, M., *Le avanguardie artistiche del Novecento*, Feltrinelli, Milano 1971.

Dorfles, G., *Le oscillazioni del gusto*, Einaudi, Torino 1970.

Id., *Elogio della disarmonia*, Garzanti, Milano 1992.

Focillon, H., *Life of Forms in Art*, Zone Books, New York 1989.

Gombrich, E.H., *Freud e la psicologia dell'arte. Stile, forma e struttura alla luce della psicoanalisi*, Einaudi, Torino 1967.

Jaffe, H.L.C., *De Stijl 1917-31; the Dutch Contribution to Modern Art*, A. Timati, London 1956.

Kubler, G., *Shapes of Time. Remarks on the History of Things*, Yale University Press, New Haven 1962.

Lippard, L.R., *Pop Art*, Thames and Hudson, London 1966.

Paci, E., *Tempo e relazione*, Il Saggiatore, Milano 1965.

Panofsky, E., *Perspective as Symbolic Form*, MIT Press, Cambridge 1991.

Richter, H., *Dada, Art and Antiart*, Oxford University Press, New York 1978.

Schapiro, M., *Lo stile*, Donzelli, Roma 1995.

Zevi, B., *Il linguaggio moderno dell'architettura. Guida al codice anticlassico*, Einaudi, Torino 1973.

Id., *Poetica dell'architettura neoplastica*, Einaudi, Torino 1974.

Language, Communication

Aa.Vv., *La comunicazione nella storia*, Seat, Torino 1994.

Baldelli, P. (ed.), *Comunicazioni di massa*, Feltrinelli, Milano 1974.

Eco, U., *La struttura assente. Introduzione alla ricerca semiologica*, Bompiani, Milano 1968.

McLuhan, M., Hutchon, K., McLuhan, E., *City as a Classroom: Understanding Language and Media*, Book Society of Canada, Agincourt 1977.

Internet Sites

Companies
ABET LAMINATI: *http://www.abet-laminati.it*
ALESSI: *http://www.alessi.com*
ALFA ROMEO: *http://www.alfaromeo.com*
ARTEMIDE: *http://www.artemide.com*
B&B ITALIA: *http://www.bebitalia.it*
FABBIAN: *http://www.fabbian.com*
FERRARI: *http://www.ferrari.it*
FIAM ITALIA: *http://www.fiamitalia.it*
FIAT: *http://www.fiat.com*
FONTANA ARTE: *http://www.fontanaarte.it*
PEUGEOT: *http://www.peugeot.it*
RENAULT: *http://www.renault.it*

REX-ZANUSSI: *http://www.rex.zanussi.it*
SIEMENS: *http://www.siemens.it*
TARGETTI: *http://www.targetti.it*
TEUCO: *http://www.teuco.it*
VITRA: *http://www.vitra.com*
ZANOTTA: *http://www.zanotta.it*

Designers & Stylists
BENETTON: *http://www.benetton.com*
CASTIGLIONI: *http://www.moma.org/exhibitions/castiglioni*
FERRÉ: *www.gianfrancoferre.com*
GIUGIARO / ITALDESIGN: *http://www.nes.it/italdesign/home.htm*
LANG: *http://www.helmutlang.com*
MOSCHINO: *http://www.moschino.it*
PININFARINA: / http://www.pininfarina.it
RUGGERI: *http://www.cinziaruggeri.com/designer.html*
SAINT LAURENT: *http://www.yslonline.com*
SOWDEN: *http://www.georgesowden.com*
TRUSSARDI: *http://www.trussardi.it*

Online Magazines
CARDESIGN: *http://www.cardesignnews.com*
DOMUS: *http://www.edidomus.it/domus*
I.D. MAGAZINE ONLINE: *http://www.idonline.com*
METROPOLIS MAGAZINE: *http://www.metropolismag.com*
MODAITALIA: *http://www.modaitalia.net*
TOTEM: *http://www.totemweb.com*
VISION OF THE FUTURE: *http://www.philips.com/design/vof/toc1/home.htm*

Salons & Museums
COOPER-HEWITT NATIONAL DESIGN MUSEUM: *http://www.si.edu/ndm*
FUTURSHOW: *http://www.futurshow.it*
MUSEO DELLA PLASTICA: *http://www.sandretto.it/museo*
PITTI CASA: *www.pittimmagine.com*
INTERNATIONAL FURNITURE SALON – KOELN: *http://www.koelnmesse.de*
SMAU CADD: *http://www.smau.it/magellano/cadd*
MILAN TRIENNAL: *http://www.triennale.it*

The Information Technology Revolution in Architecture is a new series reflecting on the effects the virtual dimension is having on architects and architecture in general. Each volume will examine a single topic, highlighting the essential aspects and exploring their relevance for the architects of today.

Series edited by **Antonino Saggio**

Other titles in this series:

Information Architecture
Basis and future of CAAD
Gerhard Schmitt
ISBN 3-7643-6092-5

HyperArchitecture
Spaces in the Electronic Age
Luigi Prestinenza Puglisi
ISBN 3-7643-6093-3

Digital Eisenman
An Office of the Electronic Era
Luca Galofaro
ISBN 3-7643-6094-1

Digital Stories
The Poetics of Communication
Maia Engeli
ISBN 3-7643-6175-1

Virtual Terragni
CAAD in Historical and Critical Research
Mirko Galli / Claudia Mühlhoff
ISBN 3-7643-6174-3

Natural Born CAADesigners
Young American Architects
Christian Pongratz / Maria Rita Perbellini
ISBN 3-7643-6246-4

New Wombs
Electronic Bodies and Architectural Disorders
Maria Luisa Palumbo
ISBN 3-7643-6294-4

New Flatness
Surface Tension in Digital Architecture
Alicia Imperiale
ISBN 3-7643-6295-2

For our free catalog please contact:

Birkhäuser – Publishers for Architecture
P. O. Box 133, CH-4010 Basel, Switzerland
Tel. ++41-(0)61-205 07 07; Fax ++41-(0)61-205 07 92
e-mail: sales@birkhauser.ch
http://www.birkhauser.ch